T0288185

FANZINE GRRRLS
THE DIY REVOLUTION IN FEMALE
SELF-PUBLISHING

Copyright©2018 Instituto Monsa
de Ediciones

Editor and project director
Anna Minguet

Concept, project's selection and design
Gemma Villegas (Monsa Publications)

Text editing
Monsa Publications

Translation
Somos Traductores

Printing
Grafo

Cover image
The Two Fridas by Rio Yañez,
featured at Muchacha Fanzine

Back cover image
Poster by Elena Eper for Grrrl Zine Fair

Publisher
Instituto Monsa de Ediciones
Gravina 43
08930 Sant Adrià de Besòs
Barcelona, Spain
+34 933 810 050
www.monsa.com
monsa@monsa.com

Shop online
www.monsashop.com

Follow us!
Instagram @monsapublications
Facebook @monsashop

ISBN 978-84-16500-80-2 / D.L. B 9804-2018

Images of pages 18-23 by Creative Commons / Imágenes de las páginas 18-23 de Creative Commons

FANZINE GRRRLS

THE DIY REVOLUTION IN FEMALE SELF-PUBLISHING

BY GEMMA VILLEGAS

monsa

FANZINE GRRRLS

Making a fanzine is an act of rebellion, and even more if it is published and produced by a woman. Zines are thriving all over the world as a growing DIY scene led by women that develops and spreads into a welcoming audience. Self-publications on punk, feminism, anarchism, and social activism have been an integral facet of the counterculture movement and subculture since the 70s; although some still associate fanzines with those underground publications that were carried around in the 80s and 90s. Nowadays, the world of self-publishing is more alive than ever, and we find real gems for curious minds, especially if you are a woman and you care about what being a woman means.

A 'zine' is the abbreviation of 'fanzine,' a non-commercial publication, homemade and produced independently, and generally dedicated to specialized and unconventional topics in which the contents are described by pasting words and images on pages that are then photocopied, folded, and stapled. They are a fast and inexpensive way to spread ideas.

Traditionally dominated by white, straight men, the world of the zine has progressed in such a way that numerous historically marginalized groups can exercise their voice. This results in one of the most pleasant and interesting communities imaginable, which provide support and initiate discussions on many topics to talk about. The fanzine is a great way to connect and sharing ideas with like-minded people from around the world without having to meet them in person.

Protagonists Within this come back of stapled photocopies a number of publications stand out that have been launched with a clear gender component. Given the lack of opportunities to show their talent, a number of young creators have made the leap to self-publishing. They identify as women, non-binary gendered people, or transgendered. They have a lot to tell and are creating a very interesting world of models in which stereotypes fly out the window and in which self-representation, networks, and fun are the protagonists. A broad list of authors and collaborators

(illustrators, writers, photographers, designers) alternate their altruistic participation in fanzines with paid professional assignments. In some cases, self-publishing is the first step toward achieving a traditional publishing contract. In others, they are meant to be independent authors and owners of their own project from the beginning.

Subject Matter Currently, zines are hyper-specialized and from them the passions, obsessions, and demands of their creators can be deduced. Along with the usual genres such as comix in which authors such as Laura Endy (page 52), Bàrbara Alca (page 64) and Conxita Herrero (page 128) stand out, there are more specific women's topics that serve as a critique of the patriarchal system. Such is the case of Glitter Zines (page 32), whose zines address issues such as abortion, sexual abuse, or menstruation.

Hotdog (page 44) defends the voices of women and of non-binary gendered people and Muchacha Fanzine (page 38) promotes social awareness and the opening of minds.

Production One of the aspects that characterizes the fanzine is the scarcity of economic resources for its production. In spite of this, the improvement in the quality of their publications is remarkable. Now they are much more carefully made. There are examples of publications that have a high level of quality. Staples, photocopies, and home publishing are combined with printing systems such as screen printing or using a Risograph and the incorporation of inks, papers, and finishes that add value to the pieces. It is common to find a lot of diversity in the formats and binding with a spine such as the zine Girls from Today by Andrea Savall (page 26) or stitched, as can be seen in Space Invasion; A Piece of Cake by Gemma Davis (page 116).

Some critical voices brand this evolution as disguising the fanzine as a professional publication and giving it excessive sophistication. There are those who find fault with the new generation of fanzines for getting away from the purity and

characteristics of their original essence. Even so, this new wave of freshness and visual richness seems completely unstoppable for those who enjoy it.

Distribution Along with the classic way of distributing zines in a non-technological manner at concerts, meetings, fairs, record stores, alternative bookstores, or state regulation, we must add the distribution of these through online sales platforms such as Etsy or Bigcartel, which the creators incorporate on their websites. Advertising is vital, and the authors do not neglect it. Many of them are very good at managing the social networks that they use such as 'guerrilla marketing' to spread their zines. However, despite the phenomenon of Tumblr, for many of them paper format is still the preferred medium.

E-zine In many ways, the perzine, or personal publication, could be considered the predecessor of the blog. The incorporation of the e-zine symbolizes a new resurgence of the zines. The internet, the ease of using publishing programs, and the immediate access to social networks have facilitated distribution and formatting so that the publication of fanzines has been expanded to the net. If the printed zines pass from hand to hand, the e-zines are passed from 'tweet' to 'tweet' or from 'Issuu' to 'Issuu.' Proposals from the digital world are included in *Fanzine Grrrls*, such as that of Elisa Riera (page 102), who uses Instagram exclusively to upload her cartoons as a type of infinite comic strip.

Today's scene Although the format has changed, what these people demand remains the same: dismantle the gender roles offered by the media as well as the language used to define them. We find people who are coming together to create and distribute the kind of creative and witty content they want to listen to without the restrictions or regulations that the mainstream press often brings, replete with sensational headlines to attract clicks and loaded with advertising.

Admirable people in the zine scene are creating and promoting concerts, screenings, workshops, exhibitions, fairs, and libraries, as Lu Williams does with *Grrrl Zine Fair* (page 58). They offer support and receive new members from all over because there is a lot to be involved in. There are brilliant women behind the best publications on zine DIY culture, some of them included in this book.

The girrrls of today inspire many young women around the world to take control of their lives, to empower themselves and to create their own culture. If the fanzine is more alive than ever, how can we not want to get involved?

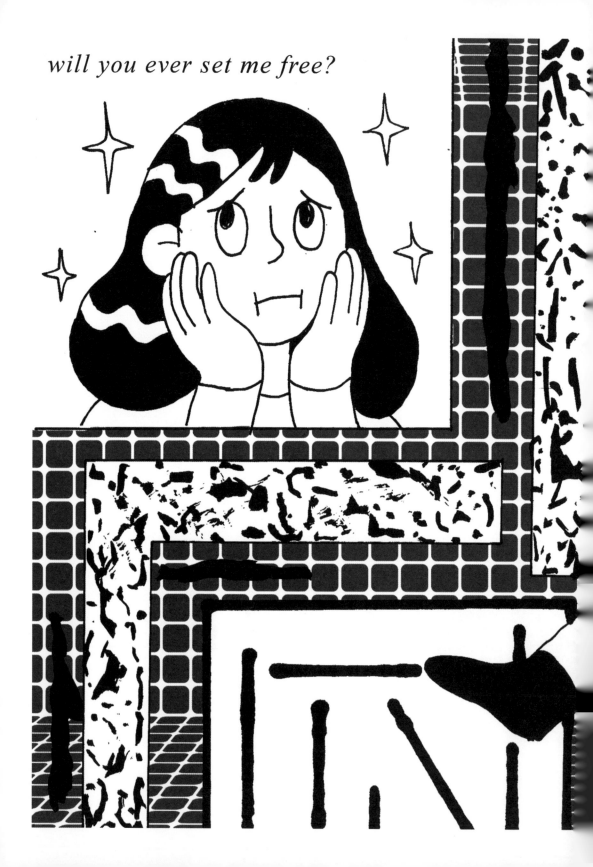

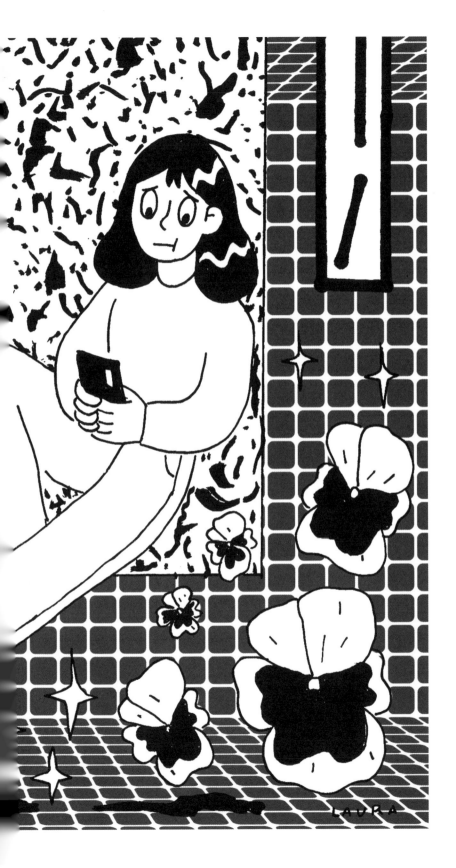

Illustration by
Laura Endy

Hacer un fanzine es un acto de rebeldía, y más aún si lo edita y autoproduce una mujer. Los zines están tomando gran repercusión en todo el mundo, gracias a una creciente escena DIY dirigida por mujeres que se desarrolla y distribuye entre un público muy acogedor. Las autopublicaciones sobre el punk, el feminismo, el anarquismo y el activismo social han sido una faceta integral de la contracultura y la subcultura desde los años 70; aunque todavía muchos relacionan los fanzines con las publicaciones *underground* de los años 80 y 90, actualmente en el mundo de la autoedición encontramos auténticas joyas para mentes curiosas, sobre todo si eres mujer y quieres saber lo que significa serlo.

Un 'zine' es la abreviatura de 'fanzine', una publicación no comercial, casera y producida de forma independiente y generalmente dedicada a temas especializados y poco convencionales en los que los contenidos se formalizan pegando palabras e imágenes en páginas que luego se fotocopian, doblan y grapan. Son una manera rápida, fácil y barata de difundir ideas.

Tradicionalmente dominado por hombres blancos y heterosexuales, el mundo del zine ha progresado de tal forma en la que múltiples colectivos históricamente marginados puedan ejercer su voz. Esto da como resultado una de las comunidades más agradables e interesantes que se puedan imaginar, las cuales brindan medios de apoyo e inician debates sobre muchos temas de los que hablar. El fanzine es una forma genial de conectar con la gente y compartir ideas afines alrededor del mundo sin tener que conocerse en persona.

Protagonistas Existe un renacer del fanzine ante la falta de oportunidades para mostrar talento; entre grapas y fotocopias, destaca la cantidad de publicaciones puestas en marcha con un claro componente de género. Muchas jóvenes creadoras han dado el salto a la autoedición; mujeres, personas de género no-binario o transgénero tienen mucho que contar y están creando referencias muy interesantes en las que los estereotipos vuelan por los aires,

y donde la diversión y las redes son las claras protagonistas. Un amplio elenco de autoras y colaboradoras (ilustradoras, escritoras, fotógrafas y diseñadoras) alternan su participación altruista en fanzines con encargos profesionales remunerados. En algunos casos, la autoedición supone el primer paso para lograr un contrato de edición tradicional; en otros, estas se configuran desde el inicio como autoras independientes dueñas de su propio proyecto.

Temática Actualmente los zines están hiperespecializados, y de ellos se desprenden las pasiones, obsesiones o reivindicaciones de sus creadoras. Junto a los géneros de siempre como el cómic *underground* en los que destacan autoras como Laura Endy (pág. 52), Bàrbara Alca (pág. 64) o Conxita Herrero (pág. 128), se unen temáticas más propias del género femenino como la crítica al sistema patriarcal; es el caso de Glitter Zines (pág. 32), cuyos zines abordan temas como el aborto, los abusos sexuales o la menstruación.

Hotdog (pág. 44) defiende las voces de las mujeres y de las personas de género no-binario, y *Muchacha Fanzine* (pág. 38) promueve la conciencia social y la descolonización de las mentes.

Producción Uno de los aspectos que caracterizan al fanzine es la escasez de recursos económicos para su producción. A pesar de ello, la mejora de la calidad de las publicaciones es bien notable; ahora las ediciones están mucho más cuidadas y hay cosas autoeditadas de gran nivel. A las grapas, fotocopias e impresión doméstica se suman el uso de sistemas de impresión como la serigrafía o la risografía y la incorporación de tintas, papeles y acabados que aportan valor añadido a las piezas. Es habitual encontrar mucha diversidad en los formatos y piezas encuadernadas con lomo, como el zine *Girls from Today* de Andrea Savall (pág. 26) o cosidos, como se puede apreciar en *Space Invasion; A Piece of Cake* de Gemma Davis (pág. 116).

Algunas voces críticas tachan esta evolución de disfrazar al fanzine de publicación profesional y dotarlo de excesiva sofisticación. Hay quienes reprochan a las nuevas generaciones fanzineras de estar alejándolo de la pureza y características propias de su esencia original. Aun así, esta nueva ola de frescura y riqueza visual parece del todo imparable para los que la disfrutan.

Distribución A la forma de distribución clásica de los zines en conciertos, encuentros, ferias, tiendas de discos o librerías alternativas que llegan a lugares sin tecnología y sin regulacion del estado, hay que sumar la difusión de estos mediante plataformas de venta online como Etsy, Tictail o Bigcartel, que las creadoras incorporan en sus webs. La promoción es vital y las autoras no la descuidan. A muchas de ellas se les da muy bien manejar las redes sociales, que usan como 'marketing de guerrilla' para difundir sus zines. Sin embargo, a pesar del fenómeno del Tumblr, para muchas de ellas el formato en papel sigue siendo el medio preferido.

Ezine En muchos sentidos, el *perzine* o publicación personal podría considerarse el papel predecesor del blog. La incorporación del *ezine* simboliza un nuevo resurgimiento de los zines; internet y la facilidad para usar programas de edición y el inmediato acceso a las redes sociales han facilitado la distribución y los formatos, por lo que la edición de fanzines se ha extendido por las redes. Si los zines impresos pasan de mano en mano, los *ezine* lo hacen de 'tuit' en 'tuit' o de Issuu en Issuu. En *Fanzine Grrrls* se incluyen propuestas del mundo digital, como la de Elisa Riera (pág. 102) que usa exclusivamente Instagram para subir sus viñetas a modo de cómic infinito.

Escena actual Aunque el formato ha cambiado, lo que estas mujeres defienden sigue siendo lo mismo: desarmar los roles de género que brindan los medios de comunicación así como el lenguaje utilizado para definirlas. Encontramos personas que se están uniendo para crear y distribuir el tipo de contenido creativo e ingenioso

creativo e ingenioso que desean escuchar, sin las restricciones ni regulaciones que a menudo conlleva la prensa convencional, repleta de titulares sensacionalistas para atraer clics y cargada de publicidad.

Personas admirables en la escena del zine están creando y promoviendo conciertos, proyecciones, talleres, exposiciones, ferias y bibliotecas, como hace Lu Williams con *Grrrl Zine Fair* (pág. 58). Ofrecen apoyo y reciben nuevos miembros de todas partes, porque hay mucho en lo que implicarse. Detrás de las mejores publicaciones sobre la cultura del zine DIY se hallan perfiles brillantes, muchos de ellos incluidos en este libro. Las grrrls de hoy en día inspiran a infinidad de jóvenes alrededor del mundo a tomar el control de sus vidas, a empoderarse y a crear su propia cultura. Si el fanzine está más vivo que nunca, ¿Cómo no nos vamos a querer involucrar?

Origin

The origins of fan publications can be traced back to 19th century literary groups in the United States, when the Amateur Press Association published collections of fiction, poetry, and commentary. They had H. P. Lovecraft as one of their biggest representatives.

Howard Phillips Lovecraft

Origen

Los orígenes de las publicaciones fan se remontan a los grupos literarios del siglo XIX en los Estados Unidos, donde la Amateur Press Association publican *apazines*, colecciones de ficción, poesía y comentario con H. P. Lovecraft como uno de sus mayores representantes.

1914
The Little Review

Jane Heap and Margaret Anderson publish the celebrated literary magazine *The Little Review*, a form of self-publishing close in spirit to the fanzine that brings together an extraordinary collection of modern American and European writers.

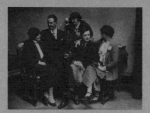

Jane Heap, John Rodker, Martha Dennison, Tristan Tzara, Margaret Anderson, ca. 1920s

The Little Review

Jane Heap y Margaret Anderson editan la célebre revista literaria *The Little Review*, una forma de autopublicación cercana en espíritu al fanzine que aúna una colección extraordinaria de escritores modernos americanos y europeos.

1916
Dadaism

Dadaism was born as an intellectual and aesthetic vanguard movement that proposes the opposite of the concept of reason, a denial of everything and destruction through destruction.
— Their artists produce and distribute small books as art zines.
— The use of collage, appropriation and stamping influence subsequent fanzines.

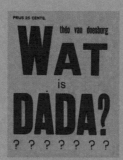

What is Dada?
Theo van Doesbrug, 1923

Dadaísmo

El Dadaísmo nace como un movimiento de vanguardia intelectual y estético que propone lo opuesto al concepto de razón la negación de todo y la destrucción por la destrucción.
— Sus artistas producen y distribuyen pequeños libros a modo de *art zines*.
— El uso del *collage*, la apropiación o la estampación influyen en los fanzine posteriores.

1926
Amazing Stories

Readers of the professional magazine *Amazing Stories* send their own stories in exchange for the magazine publishing their names and addresses in order to start correspondence with other readers.
— There is a strong community of fans that exchange ideas and stories.
— *Amazing Stories* helps define and launch a new genre of pulp fiction.

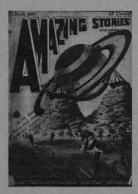

Amazing Stories
Volume 1, Issue 1, April 1926

Amazing Stories

Los lectores de la revista profesional *Amazing Stories* envían sus propias historias a cambio de que la revista publique sus nombres y direcciones para iniciar correspondencia con otros lectores.
— Se entabla una potente comunidad de fans que intercambian ideas e historias.
— *Amazing Stories* ayuda a definir y poner en marcha un nuevo género de ficción *pulp*.

1930
The Comet

The Science Correspondence Club in Chicago publishes *The Comet*, the first science fiction fanzine.
— Fandom science-fiction clubs publish their own fan magazines or fanmags.
— The mimeograph emerges as a cheap medium that facilitates the production and distribution of fanmags.

Mimeograph

The Comet

El Science Correspondence Club en Chicago publica *The Comet*, el primer fanzine de ciencia ficción.
— Los clubes de ciencia ficción *fandom* publican sus propios *fanmagazines* o *fanmags*.
— El mimeógrafo emerge como medio barato que facilita la producción y distribución de los *fanmags*.

1940
Fanzine Term

Russ Chauvenet, author of the zine *Detours* and one of the founders of the fandom of science-fiction, coined the term fanzine (a combination of fanmag and letterzine) in order to distinguish them from prozines, professional journals of the genre.

The Fanscient No.8
(The Robert Bloch Issue)
Page 13 Summer 1949

Término *Fanzine*

Russ Chauvenet, autor del zine *Detours* y uno de los fundadores del *fandom* de ciencia-ficción, acuña el término *fanzine* (unión de *fanmag* y *letterzine*) para distinguirlos de los *prozines*, revistas profesionales del género.

1950
Beat Generation

The groups of writers of the Beat Generation encourage the racial, women, and gay liberation movements as well as the rise of the hippie counterculture as a rejection of the classic values of society.
— They mimeograph small runs of their own chapbooks.
— They use self-publishing and their own distribution channels to disseminate their radical works due to the difficulty of doing so through the current means of the time. These events represent a milestone in the history of the fanzine.

Allen Ginsberg,
American beat poet

Generación Beat

Los grupos de escritores de la Generación Beat fomentan los movimientos de liberación racial, de la mujer, los homosexuales y el ascenso de la contracultura *hippie* en rechazo a los valores clásicos de la sociedad.
— Imprimen con mimeógrafos pequeños tirajes de sus propios *chapbooks*.
— Emplean la autoedición y sus propios canales de distribución para difundir sus radicales obras, debido a la dificultad de hacerlo a través de los medios corrientes de la época. Estos hechos suponen un hito en la historia del fanzine.

1957
Situationism

The fanzine becomes one of the main means of expression of the counterculture at the hands of the situationist revolutionary intellectuals in Paris.
— This artistic-political group redefines the limits of art and fights the capitalist ideological system.
— The Fluxus collective creates a movement of exchange and communication through Mail Art.
— They self-publish pamphlets in which they divulge their concept of art as part of everyday life and not as an activity for the enjoyment of elite minorities.
— They include an anticopyright section in their publications.

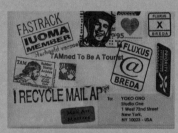

Mail Art letter from Fluxus
to Yoko Ono

Situacionismo

El fanzine se convierte en uno de los principales medios de expresión de la contracultura de la mano de los intelectuales revolucionarios situacionistas en París.
— Este grupo artístico-político reescribe los límites del arte y combate el sistema ideológico capitalista.
— El colectivo Fluxus crea un movimiento de intercanvio y comunicación a través de la actividad artística del Mail Art.
— Autoeditan panfletos en los que divulgan su concepto del arte como parte de la vida cotidiana y no como actividad para el disfrute de minorías elitistas.
— Incluyen un apartado *anticopyright* en sus publicaciones.

1960
Zap Comix

The North American authors of underground comics in the 60s and 70s and the text on the net in copyleft format represent two major events in the course of the fanzine. Robert Crumb founds Zap Comix, the first comic zine in which he deals with subjects that were taboo for society at the time like sex or drugs.

Copyleft symbol

Zap Comix

Los autores norteamericanos de comics underground de los 60 y los 70 y el texto en la red en formato *copyleft* representan dos grandes acontecimientos en el curso del fanzine. Robert Crumb funda Zap Comix, el primer zine de historietas en el que trata temas tabú para la sociedad del momento como el sexo o las drogas.

Antisystem
Phenomenon

The typewriter and low-cost publishing media such as the duplicator, photocopier, and offset printing allowed the printing of anti-system publications and was accessible to student groups, anti-war activists, feminists, LGBT collectives, trade unionists, pacifists, and other activists for freedom of expression.

Peace symbol

Fenómeno antisistema

La máquina de escribir y los medios de edición de bajo coste como la multicopista, la fotocopiadora y la impresión en offset permiten producir prensa antisistema accesible a grupos estudiantiles, antibelicistas, feministas, colectivos LGTB, sindicales, pacifistas y demás activistas por la libertad de expresión.

1970
Punk and DIY

Punk breaks into the scene as a nihilistic and destructive movement, preceded by the wave of garage rock, Situationism, and Transgression.
— They disagree with stereotypes, the rules of aesthetics, and everything mainstream in general.

— They express themselves in concerts where they would exchange records, photos, pamphlets, and zines.
— Punk fanzines reveal the frustration and anger of the youth of the time through DIY philosophy and lo-fi techniques in the form of slogans, the twisting of commercial advertisements, and appropriationism.

UK fanzines from the punk and immediate post-punk era

Punk y DIY

El punk irrumpe en escena como movimiento nihilista y destructivo, precedido por la corriente del *garage rock*, el Situacionismo y la Transgresión.
— Discrepan de los estereotipos, de las reglas de la estética y todo lo *mainstream* en general.
— Se expresan en conciertos donde intercambiaban discos, fotos, panfletos y zines.
— Los fanzines punks ponen de manifiesto la frustación y la rabia de la juventud de la época mediante la filosofía DIY y las técnicas *lo-fi* en forma de eslóganes, tergiversación de anuncios comerciales o apropiacionismo.

Second Feminist Wave

The second wave of feminism brings publications full of rage and contagious energy born in the United States and Britain, such as *It Ain't Me, Babe, Spare Rib*, or *Shocking Pink*.
— They appropriate insults toward women in order to turn them around with a positive identity and turn them into titles like the fanzine *Musical Bitch*.
— Fanzines are an alternative to musical magazines for teenagers, a way to break from the female stereotype in which they do not feel reflected. These DIY publications show their writing, art, and a new form of self-representation.

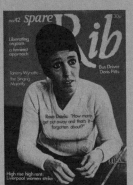

Spare Rib
Issue 42, mid-1970s

Segunda ola feminista

La segunda ola del feminismo trae publicaciones repletas de rabia y energía contagiosa nacidas en Estados Unidos y Gran Bretaña, como *It Ain't Me, Babe, Spare Rib* o *Shocking Pink*.
— Se apropian de insultos hacia las mujeres para darles la vuelta con una identidad positiva y convertirlas en títulos, como el fanzine musical Bitch.

— Los fanzines son una alternativa a las revistas musicales para adolescentes, una forma de romper con el estereotipo femenino en el que no se sienten reflejadas. Estas publicaciones DIY muestran sus escritos, su arte y una nueva forma de autorepresentación.

1980
Queerpunk

In the mid 80s, Queerpunk begins as a branch of punk. It is distinguished by its dissatisfaction with society's disapproval of gay, bisexual, lesbian, and transgender communities.
— Queercore appears within Rock and is expressed in a DIY style through fanzines, music, writing, art, and film.
— The angry grrrl zines and the homocore zines give a twist to the story of the fanzine: now the authors are girls and people belonging to the LGBTQ community.

The Ramones, who were influenced by garage-rock, spearheaded the mid-1970s punk movement in New York

Queerpunk

A mediados de los 80 se abre paso el Queerpunk como rama del punk. Se distingue por su descontento con la desaprobación de la sociedad a las comunidades

gays, bisexuales, lesbianas y transgénero.
— El Queercore aparece dentro del rock y se expresa en un estilo DIY a través del fanzine, la música, la escritura y el cine.
— Los *angry grrrl zines* y los *homocore zines* dan un giro a la historia del fanzine: ahora las autoras son chicas y personas pertenecientes a la comunidad LGTBQ.

Explosion of the Fan Phenomenon

The fanzine theme undergoes a big transformation within the fan phenomenon. The authors replace the political and vanguard contents of previous movements with more intimate and personal ones.
— The idols of the moment become the stars of the publications.
— The perzine becomes a leading genre in which the authors tell their own experiences, passions, and obsessions.
— Fairs, associations, and meetings in the field of self-publishing abound.

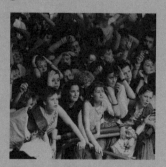

Fans in a concert of 1984

Explosión del fenómeno fan

La temática fanzinera experimenta una gran transformación con el fenómeno fan. Los autores reemplazan los contenidos políticos y rupturistas de movimientos anteriores por otros más íntimos y personales.
— Las publicaciones las protagonizan los ídolos del momento.
— El *perzine* se convierte en género protagonista en el que los autores cuentan sus propias experiencias, pasiones y obsesiones.
— Abundan ferias, asociaciones y reuniones entorno al terreno de la autopublicación.

1990
Riot Grrrl

The zines of the 90s are distinguished from the rest by the feminist movement Riot Grrrl, which came out of Olympia (Washington) and intimately linked to the visual language of punk, radical politics and DIY 'do it yourself' aesthetics.
— Meetings, fanzines, and support for women in music are part of Riot Grrrl activism.
— They refuse to remain silent in the face of the effects of patriarchy and of the discrimination of women in the mainstream media in messages with aggressive and chaotic themes.
— The Grrrl Zines combine writings of an anarchist political bent with personal stories (dreams, childhood memories, photographs, experiences with abortion, emotional break-ups, etc.).
— They highlight exemplary titles such as *Riot Grrrl* minizine, *Bikini Kill* (origin of the band with the same name), *Girl Germs*, *Jigsaw, Runt, FAT!SO?, Snarla,*

Manifixation, Sneer, More Than a Feeling and the English fanzines *Ablaze!* and *Girlfrienzy*.
— Platforms such as Riot Grrrl Press, GERLL, Riot Grrrl Review and Action Girl Newsletter contribute to its dissemination.

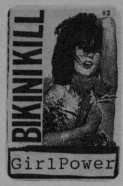

Punk band Bikini Kill's second zine *Girl Power*, 1991

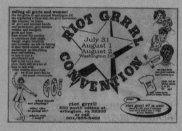

Page of the fanzine *Riot Grrrl* summoning the 'Riot Grrrl Convention', 1992

Riot Grrrl

Los zines de los 90 se distinguen del resto por el movimiento feminista Riot Grrrl, surgido en Olympia (California) e íntimamente unido al lenguaje visual del punk, la política radical y la estética DIY 'hazlo tú misma'.
— Reuniones, fanzines y apoyo a las mujeres en la música forman parte del activismo Riot Grrrl.
— Rechazan permanecer en silencio ante los efectos del patriarcado y la discriminación de la mujer en los medios

mainstream en mensajes con montajes agresivos y caóticos.

— Los *grrrl zines* combinan escritos de inclinación política anarquista con historias personales (sueños, memorias infantiles, fotografías, experiencias con el aborto, rupturas sentimentales, etc.).

— Destacan títulos de referencia como la *mini-zine Riot Grrrl, Bikini Kill* (origen de la banda del mismo nombre), *Girl Germs, Jigsaw, Runt, FAT!SO?, Snarla, Manifixation, Sneer, More than a feeling* y los fanzines ingleses *Ablaze!* y *Girlfrienzy*.

— Plataformas como Riot Grrrl Press, GERLL, Riot Grrrl Review o Action Girl Newsletter contribuyen a su difusión.

2000
From Paper to Blog

Technological advances in professional printing have an impact on the quality of the fanzine. This considerable improvement is due to two main reasons: creators' greater accessibility to computers and knowledge of digital publishing programs.

— Many fanzines circulate in CD format as a supplement to the paper version.

— The immediacy of the internet allows you to publish fanzines on blogs and websites more quickly and at a lower cost than a paper version.

Tumblr logo

Del papel al blog

Los avances tecnológicos en impresión profesional repercuten en la calidad del fanzine; este mejora considerablemente debido a dos razones principales: una mayor asequibilidad por parte de las creadoras para disponer de ordenadores y el gran conocimiento de programas de edición digital.

— Muchos fanzines circulan en formato CD como complemento a la versión en papel.

— La inmediatez de internet permite publicar fanzines en blogs i webs más rápidamente y con menor coste que su versión en papel.

2018
Social Networks

Access to the internet and the ease of layout in HTML facilitate distribution and formats, so the publication of fanzines extends to the net.

— The e-zine experiences a great boom through Issuu or Joomag platforms.

— Many authors find an alternative way to get to festivals and urban markets to sell and promote their products through social networks, online stores, and apps.

— Art galleries, bookstores, libraries and universities dedicate spaces for showing, filing, and selling fanzines.

— The resurgence of a new feminist wave and the proliferation of numerous festivals and exhibitions around the world favor the brilliant moment that the female fanzine currently enjoys.

ML image document

Redes sociales

El acceso a internet y la facilidad para maquetar en HTML facilitan la distribución y los formatos, por lo que la edición de fanzines se extiende a la red.

— El *ezine* experimenta un gran auge mediante plataformas tipo Issuu o Joomag.

— Muchas autoras encuentran en redes sociales, tiendas online y apps una vía alternativa a los festivales y mercadillos urbanos para vender y promocionar sus productos.

— Salas de arte, librerías, bibliotecas y universidades dedican espacios de muestra, archivo y venta de fanzines.

— El resurgir de una nueva ola feminista y la proliferación de numerosos festivales y exposiciones en todo el mundo favorecen el momento brillante del que goza actualmente el fanzine femenino.

○ General Zine Fests
● Grrrl Zine Fests

1 Vancouver
Canzine West/
Vancouver Art
Book Fair
2 Olympia
Olympia Zine Fest
3 Eugene
Comics & Zine Fest
4 San Francisco
SF Zine Fest
5 Los Angeles
L.A. Zine Fest
6 Montreal
Expozine
7 Toronto
Queer Zine Fest
8 Halifax
Halifax Zine Fair
9 Hamilton (Canada)
Feminist Zine Fair
10 Massachussets
Feminist Zinefest
11 Pittsburgh
Feminist Zine Fest
12 Philadelphia
Philly Feminist
Zine Fest
13 New York
NYC Feminist
Zine Fest

14 Guadalajara
Zinfuturo
15 Mexico City
Fanzinorama
16 Quito
Mayo Fanzinero
17 Guayaquil
Fanzine Fest
GFF Guayaquil
18 Barranco
Agujero negro
19 Cordoba
Fanzinate
20 Rio de Janeiro
Mostra Grampo
de Publicações
Independentes
21 Sao Paulo
Zine Die Osasco
22 Santiago de Chile
Impresionante
23 Buenos Aires
Feria Paraguay
de arte impreso/
FLIA La Plata
24 Glasgow
Glasgow Zine Fest

25 Bergen
Art Book Fair
Fanzinekveld
26 Manchester
North West Zine Fair
27 Bristol
Comic & Zine

28 London
Bent Fest
Grrrl Zine Fair
Queer Zine Fest
Weirdo Zine Fest
29 Berlin
Berlin Zinefest
30 Rennes
Le Marché Noir
31 Bordeaux
Disparate
32 Paris
Fanzines!
33 A Coruña
Autobán

34 Bilbao
Bala
35 Pamplona
Pumpk
36 Angoulême
Spin Off
37 Porto
Zine Fest PT
38 Madrid
GRAFMAD
Libros Mutantes
Pichi Fest

39 Barcelona
Atom Fast Market
Estrogenfest
Flia
Gutter Fest
Kboom!
40 Valencia
Tenderete
Trueno-Rayo Fest
41 Tenerife
Pliegue
42 Lucca
Borda!Fest
43 Macerata
Ratatà

44 Rome
Crack!
45 Warsaw
Independent Book
Fair
46 Belgrade
Novo Doba Festival
47 Athens
Athens Zinefest
48 Seoul
Seoul Zine Festival
49 Osaka
Zine Day Osaka

50 Canton
Singularity Festival
51 Sabah
Sabah Zine Fest &
Distro Day Out
52 Sydney
MCA Zine Fair
53 Melbourne
Grrrl Fest
54 Auckland
Auckland Zinefest

Real Lives of Modern Women in the First Person

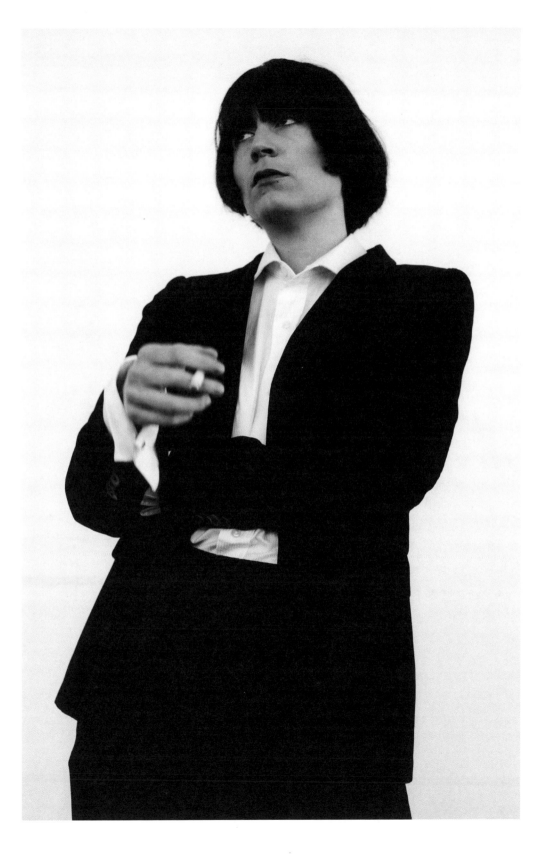

Andrea Savall is a photographer who lives in Madrid, Spain. She combines her professional life working at vogue.es and collaborating with different designers on personal projects. *Girls From Today* is the best currently known. This is a feminist fanzine with which she intends to document what the girls of today are really like, with a look from inside and asking many women.

The first issue came out in January 2017. It gathered together letters, emails, and whatsapps written by women about how they felt living within their gender. The prologue of this issue reads 'The history of women today cannot be told only once.'

The second one focused on women in art, in which more than 10 women told how they felt in their artistic careers: Carlotta Cosials of the band Hinds, Candela Capitán and María Rosenfeldt, among others. For her, it is very important that fanzines do not only give their opinion, but rather that of all the girls who participate in it.

Girls From Today has appeared on Radio 3, in the magazine *Glamour*, and in Arco 2017 and 2018, as well as in numerous online publications such as *Tentaciones*, *Vein*, *Yorokobu*, *Vice*, *Madriz*, among others. *Girls From Today* is a totally self-published project by the author.

Andrea Savall es una fotógrafa que vive en Madrid, España. Compagina su vida profesional trabajando en vogue.es y colaborando con diferentes diseñadores en proyectos personales. *Girls From Today* es el más conocido actualmente. Este es un fanzine feminista con el que pretende documentar cómo son en realidad las chicas de hoy en día, con una mirada desde dentro y preguntando a muchas mujeres.

El primer número salió en enero de 2017; este recogía cartas, *emails* y *whatsapps* escritos por mujeres sobre cómo se sentían viviendo en su género. El prólogo de este número reza 'La historia de las mujeres de hoy no se puede contar de una sola vez'.

El segundo se centró en la mujer en el arte, en el que más de 10 mujeres contaron cómo se sentían en sus carreras artísticas: Carlotta Cosials de la banda Hinds, Candela Capitán y María Rosenfeldt, entre otras. Para ella es muy importante que los fanzines no cuenten únicamente su opinión, sino la de todas las chicas que participan en él.

Girls From Today ha aparecido en Radio 3, en la revista *Glamour* y en Arco 2017 y 2018, además de en numerosas publicaciones online como *Tentaciones*, *Vein*, *Yorokobu*, *Vice*, *Madriz*, entre otras. *Girls from today* es un proyecto totalmente autoeditado por la autora.

← Marta Pastor on the cover of Fanzine 1
→ Carlotta Cosials in Fanzine 2 *Mamá, quiero ser artista*

Text & image courtesy of Andrea Savall

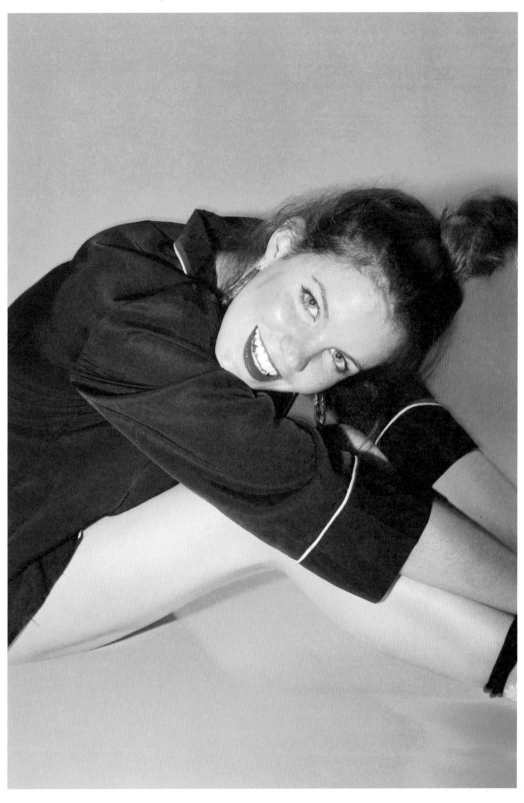

Mamá, quiero ser
artista

Girls from today / 29

1

2

3

TO BE A BLACK YOUNG WOMAN IN THE MUSIC INDUSTRY IS A CHALLENGE.
THE LACK OF DIVERSITY AND FEMALE REPRESENTATION IN SENIOR EXECUTIVE
ROLES REFLECTS OUR UNEQUAL SOCIETY IN TERMS OF LABOR MARKET
BARRIERS AND OPPORTUNITIES. THE ORGANISATION OF FESTIVALS, LABELS,
PRODUCERS, VENUE OWNERS, TECHNICIANS AND SOUND ENGINEERS, MANAGERS,
PROMOTERS ... AS A GENERAL RULE, THE MAJORITY OF THESE JOBS ARE
PERFORMED BY MEN. MEN RUN THE INDUSTRY, BUT WHY?
WHAT DOES IT IMPLY? THIS ASYMMETRICAL RELATIONSHIP OF POWER
BETWEEN MEN AND WOMEN IS A HIDDEN OBSTACLE FOR FEMALE
ARTISTS, COMPOSERS, SINGERS, MUSICIANS BECAUSE WE ARE OBSERVED
FROM A REDUCTIONIST MALE POINT OF VIEW. OUR KNOWLEDGE IS CONSTANTLY
PUT INTO QUESTION, WE HAVE TO DEAL WITH SEXUAL OBJECTIFICATION ON A
DAILY BASIS, AND OUR BODIES BECOME MORE RELEVANT THAN WHAT WE
ACTUALLY WANT TO COMMUNICATE. TO BE BEAUTIFUL, ACCORDING TO
THE SOCIALLY ACCEPTED CANON OF BEAUTY, AND TO HAVE A SWEET
SOFT VOICE ARE INDISPENSABLE REQUIREMENTS TO SUCCEED AND ALSO
THE BEST COMPLIMENTS WE CAN GET. WE HAVE TO DEAL WITH STEREOTYPES
AS WELL, LIKE OUR SONGS ALL HAVE TO TALK ABOUT MEN THAT BROKE OUR HEARTS — ALWAYS
TAKING FOR GRANTED OUR HETEROSEXUALITY, OF COURSE — OR THAT SOMEONE
ELSE WRITES OUR SONGS — OH, WAIT, DID YOU WRITE THIS? LIKE, THE WHOLE
SONG? AS IF THERE WASN'T A 'THINKING MIND' BEHIND MY PRETTY FACE,
AS IF I WAS JUST A PRODUCT. IT SEEMS LIKE IF WE ARE SMART
THE BEST THING WE CAN DO IS PLAY THE CARDS WE ARE DEALT,
BUT THOSE WHO DEAL THE CARDS NEVER PLAY FAIR.

THERE'S THIS GLASS CEILING JUST A FEW INCHES ABOVE
OUR HEADS. FOR SOME REASON WE REFUSE TO APPROACH THIS
ISSUE BUT WE ALL KNOW IT'S THERE. HOW CAN I ACCEPT THAT?
I HAVE ALL MY LIFE TO LIVE, ALL MY WORDS TO GIVE, AND
A HUGE DESIRE TO CREATE.

MAREM LADSON

4

↑ → Fanzine 2
Mamá, quiero ser artista
1 Single page

2 Marem Ladson dressed
by Heridadegato
3 Cintila Lund

4 Marem Ladson's text on how
to be an artist being young
and a woman nowadays

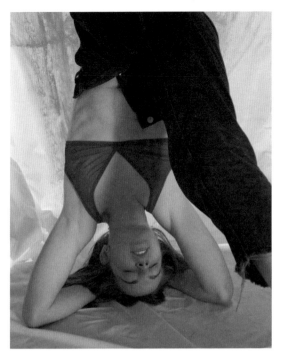

5

6

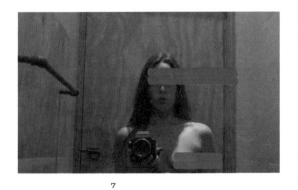

7

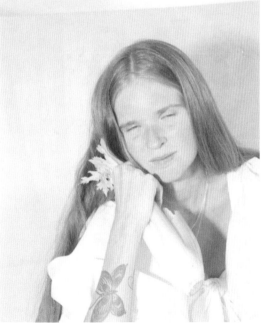

8

5 Candela Capitán
6 Macarena Savall,
Summer of 2017

7 Self-portrait by
Andrea Savall
8 María Rosenfeldt

GLITTER ZINES

Myths and Legends from a Feminist Perspective

BARCELONA

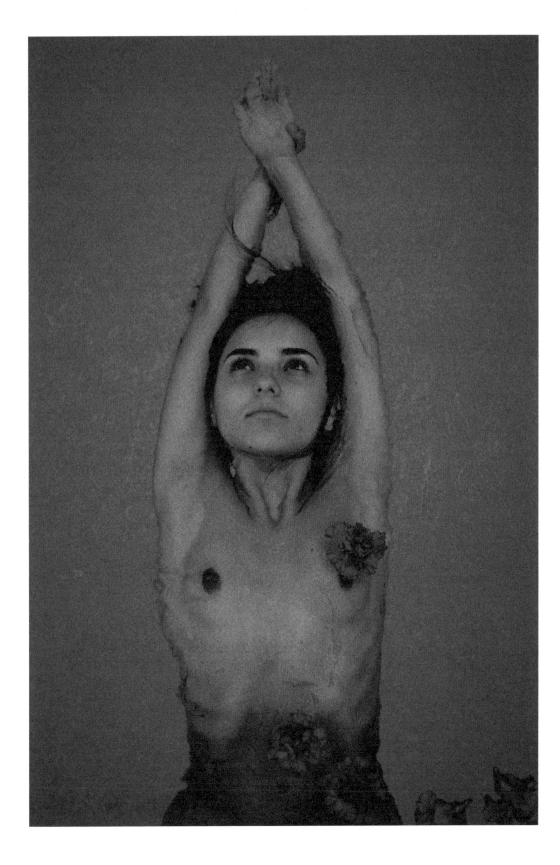

Glitter Zines is an independent publishing project formed in 2015 by Henar Bengale (photographer and graphic designer), Patricia Aguilar (photographer) and Elena Barrio (poet and editor) that experiments with literature, photography and illustration in fanzine format. With each publication, the members of this collective reinterpret myths and legends, fruits of the patriarchal culture and tradition, from a feminist perspective. The goal is to refute, rewrite, and appropriate them.

With their first fanzine, *Nietas de la Hoguera* (2015), Glitter Zines regained the memory of those women who were burned in Europe between the 15th and 18th centuries, accused of witchcraft, for being independent, free, or simply different women. Since then, in different fanzines, all with a pop aesthetic characteristic, sensitive photographs and critical and poignant poetry have put forgotten scientists and astronauts on the table (*Supernova*, 2016), the subject of menstruation (*Fluir*, 2017) and women mistreated by the patriarchy in the form of a mermaid (*Pieles de neón*, 2017), among other topics. All this to be included in the feminist discussion, from an arts perspective, for anyone who wants to listen.

Glitter Zines es un proyecto editorial independiente formado en 2015 por Henar Bengale (fotógrafa y diseñadora gráfica), Patricia Aguilar (fotógrafa) y Elena Barrio (poeta y editora) que experimenta con la literatura, la fotografía y la ilustración en formato fanzine. Con cada publicación, las integrantes de este colectivo reinterpretan mitos y leyendas, frutos de la cultura y tradición patriarcal, desde un prisma feminista. El objetivo es rebatirlos, reescribirlos y apropiarse de ellos.

Con su primer fanzine, *Nietas de la hoguera* (2015), Glitter Zines recuperó la memoria de aquellas mujeres a las que quemaron en Europa entre los siglos XV y XVIII, acusadas de brujería, por ser mujeres independientes, libres o, simplemente, diferentes. Desde entonces, en diferentes fanzines, todos con una característica estética pop, fotografías sensibles y poesía crítica y punzante, han puesto sobre la mesa a científicas y astronautas olvidadas (*Supernova*, 2016), la temática de la menstruación (*Fluir*, 2017) y a la mujer maltratada por el patriarcado en forma de sirena (*Pieles de neón*, 2017), entre otros temas. Todo ello para incluir en el debate feminista, desde el arte, a todo el que quiera escuchar.

← Detail of *Pieles de neón*
1 Glitter Zines covers
2 *Colección Grieta* zine
3 *Pieles de neón* zine
4 *Supernova* zine
5 *Nietas de la hoguera* zine
6 *Fluir / Fluír* zine

Text & image courtesy of Glitter Zines

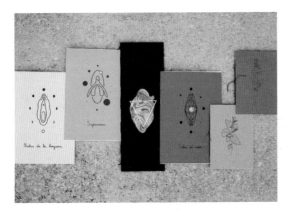

1

2

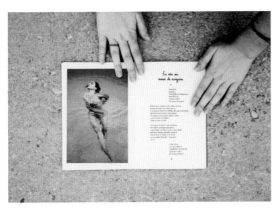

3

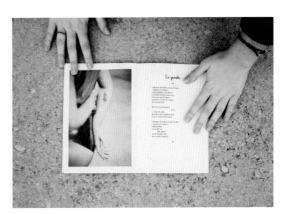

4

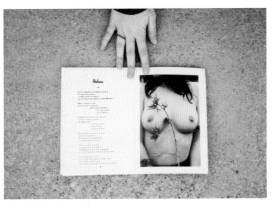

5

6

← Detail of *Supernova*
↑ Detail of *Nietas de la hoguera*

Creation of Postcolonial Feminist Spaces

Daisy Salinas is a Xicana feminist punk, community activist, bassist, artist and chingona zine queen who is new to San Antonio, Tejas. She is the creator and editor of *Muchacha*, a DIY Xicana feminist fanzine started in 2010 and dedicated to promoting social consciousness and decolonizing minds.

Her goal is to heal the wounds of her ancestors through not only surviving but also cultivating and thriving in the creation of DIY postcolonial feminist artistic spaces that are vital to our existence and survival.

She is currently starting up feminist/POC/queer-centered art and music shows at her house venue Casa Sin Vergüenza and plays bass and sings with her new band, Frijolera Riot. She lost her closest cousin Alberto Vela in June of 2016. Everything she accomplishes in this life is in his honor.

She cultivates her strength from the revolutionary women that came before, like her anarchist heroine Lucy Parsons, who Chicago PD described as 'more dangerous than a thousand riots'. As a woman of color, she wants to write about the fact that her tenacity and fierceness in the face of relentless struggle is born from the revolutionary women of color that came before. She feels a strong sense of obligation to keep their stories alive.

Text & image courtesy of Daisy Salinas

Daisy Salinas es una punk feminista *Xicana*, activista de la comunidad, bajista, artista y reina de los fanzines *chingones*, nueva en San Antonio, Tejas. Es la creadora y editora de *Muchacha*, una fanzine feminista *Xicana*, de tipo DIY que comenzó en 2010 y que se dedica a promover la conciencia social y descolonizar las mentes.

Su objetivo es sanar las heridas de sus antepasados, no solo sobreviviendo sino también cultivándose y prosperando en la creación de espacios artísticos feministas poscoloniales con el estilo 'hazlo tú mismo', los cuales son vitales para nuestra existencia y supervivencia.

Actualmente está comenzando un espectáculo de arte y música feminista / personas (POC) / *queer* en su casa llamada 'Casa Sin Vergüenza'; además, toca el bajo y canta con su nueva banda, Frijolera Riot. Perdió a su primo más cercano, Alberto Vela, en junio de 2016. Todo lo que logra en esta vida es en su honor.

Cultiva su fuerza en nombre de las mujeres revolucionarias que vinieron antes como, por ejemplo, su heroína anarquista Lucy Parsons, a la cual describió la policía de Chicago como 'más peligrosa que mil disturbios'. Como mujer de color (WOC), quiere escribir sobre el hecho de que su tenacidad y ferocidad frente a la lucha implacable nace de las revolucionarias mujeres de color que vinieron antes. Siente una fuerte sensación de obligación de mantener sus historias con vida.

← *The Two Fridas* by Rio Yañez, featured at the back cover of *MF Brown Queen: Latina Voices of the 21st Century*. Denton, 2013

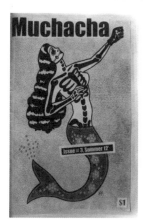
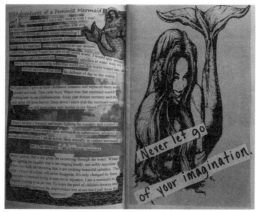

1

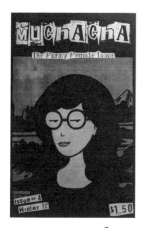

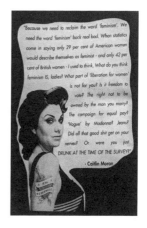

2

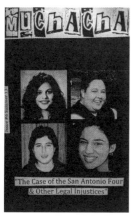

3

1 *MF The Adventures of a Feminist Mermaid.* Murfreesboro, 2012

2 *MF The Funny Female Issue.* Denton, 2012

3 *MF The Case of the San Antonio Four & Other Legal Injustices.* Denton, 2014

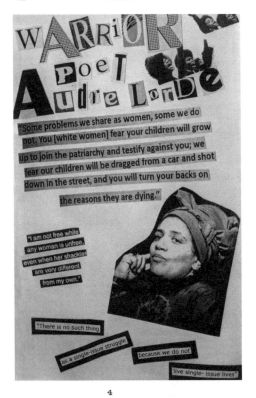

4

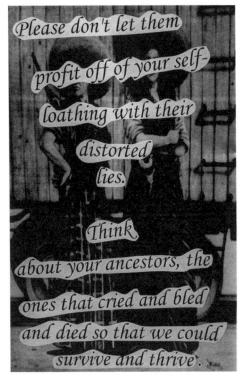

5

6

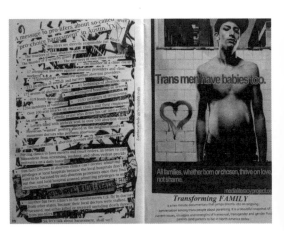

7

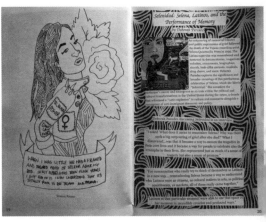

8

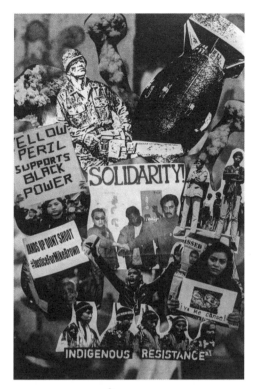

9

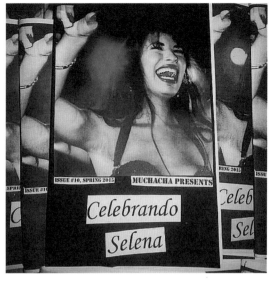

11

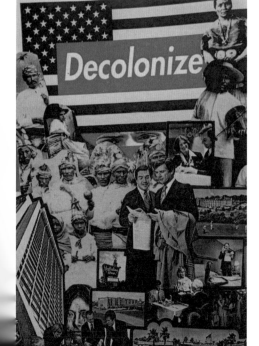

10

4 *MF The Coalition Edition.*
Denton, 2013
5-6 *MF Body Positivity.*
Denton, 2014
7 *MF Nuestros Cuerpos/Our
Bodies.* Denton, 2013
8/11 *MF Celebrando Selena.*
Denton, 2015
9 *MF POC Solidarity.*
Denton, 2016
10 *MF Decolonize Travel.*
McAllen, 2017

HOTDOG

Poetry to Restore Human Connexions

LONDON

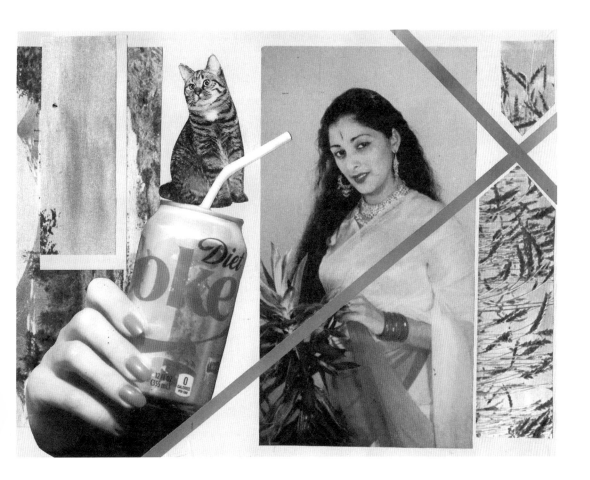

Hotdog is a poetry magazine that publishes female identifying, non-binary and transgender voices. They believe that creativity should be an honest expression of oneself—when people give them their words, images, thoughts and ideas—they take it seriously.

Hotdog is personal, painful, funny and arresting. Poetry has the power to restore and provides a conduit of human connection while people traverse the landscape of life.

In February 2018 they published issue 03: *Delightfully Unprofessional*. Throughout they explore graphically and linguistically themes that bubble to the surface: bodies, grief, loss, birth, mental health, sex, etc.

The title of this issue comes from a conversation they had with a journalist, who said they found their style 'delightfully unprofessional'. They love it. They embrace it. They take a refreshingly human and engaged approach to how they work with collaborators.

Hotdog es una revista de poesía que publica voces que se identifican como femeninas, transgénero y aquellas que no se identifican ni como mujer ni como hombre. Creen que la creatividad debe ser la expresión honesta de uno mismo; cuando la gente les brinda sus palabras, imágenes, pensamientos e ideas, ellas las toman en serio.

Hotdog es personal, dolorosa, divertida y deslumbrante. La poesía tiene poder reparador y proporciona un conducto de conexión humana mientras las personas atraviesan el paisaje de la vida.

En febrero de 2018 publicaron la edición 03: *Delightfully Unprofessional*. De principio a fin, exploran gráfica y lingüísticamente los temas que salen a la superficie: cuerpos, dolor, pérdida, nacimiento, salud mental, sexo, etc.

El título de esta edición viene de una conversación que tuvieron con un periodista, quien dijo que encontraba su estilo 'deliciosamente poco profesional'. Lo aman. Lo abrazan. Adoptan un enfoque refrescantemente humano y comprometido con la forma en que trabajan con los colaboradores.

Text and image courtesy of Hotdog

← Detail of Issue 3 *Delightfully Unprofessional* Artist & Ph: Marta Parszeniew → Issue 3 *Delightfully Unprofessional* cover & double-page spreads.

All the image credits are from Barbora Mrazkova

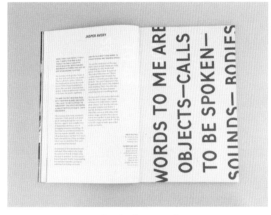

Poet: Jasper Avery Poet: Jasper Avery

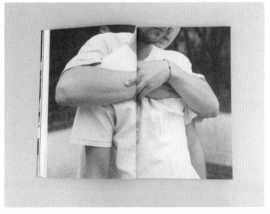

Artist: Barbora Mrazkova Artist: Barbora Mrazkova

Poet: Kate Schneider

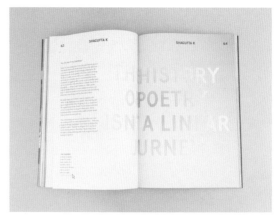

Poet: Shagufta K

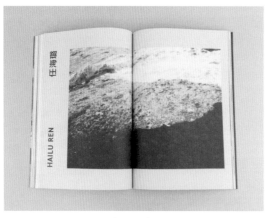

Artist: Hailu Ren

Poet: T Pomar

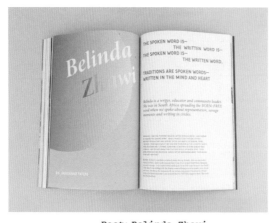

Poet: Belinda Zhawi
Interviewer: Marianne Tatepo

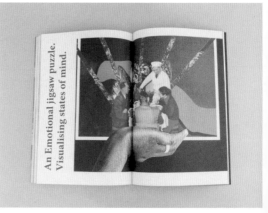

Artist: Marta Parszeniew

Detail of double-page spreads

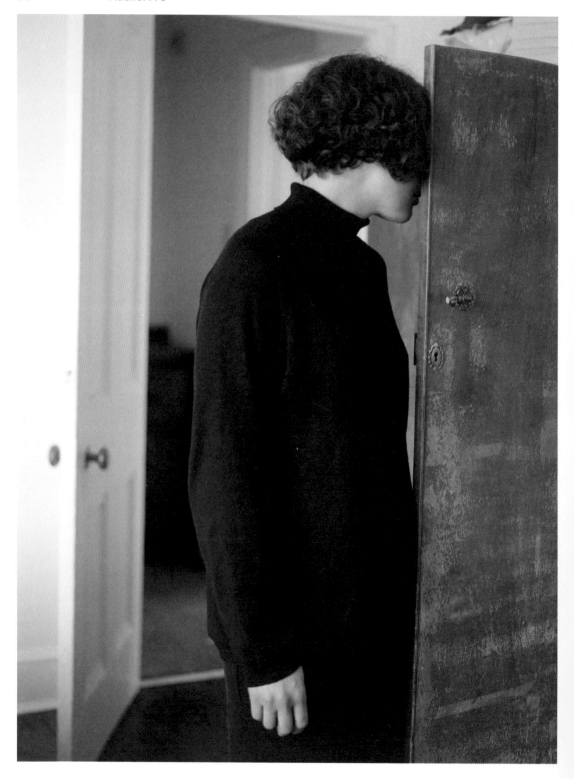

Artist: Barbora Mrazkova

Artist: Barbora Mrazkova

LAURA ENDY

Human Emotions from the Strange to the Wonderful

BARCELONA

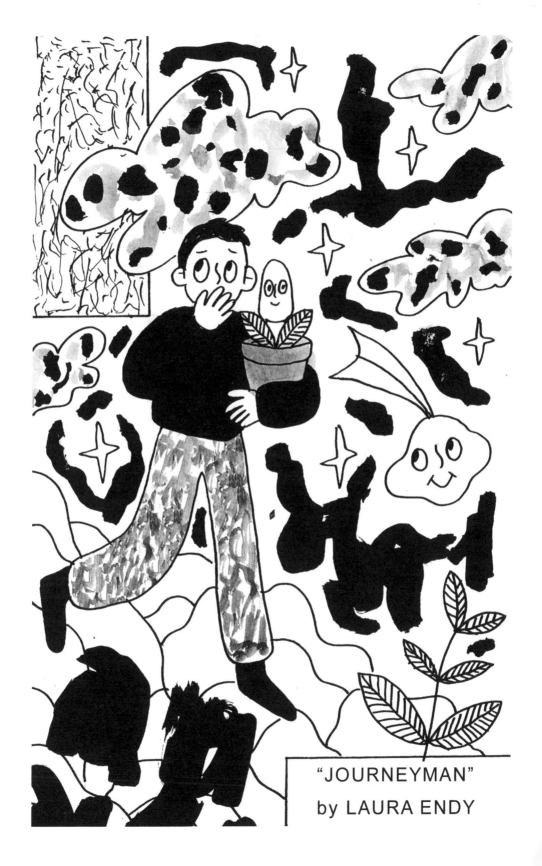

"JOURNEYMAN"

by LAURA ENDY

Laura Endy is a cartoonist. She is currently in her third year of Fine Arts at the University of Barcelona. She started making fanzines in 2016 and since then she has not stopped.

She usually creates stories in which she raises issues such as human emotions or interpersonal relationships, accompanied by drawings that move between the naïve, the strange, and the wonderful. In her comics elements appear such as water drops, pet plants, shooting stars, or colored candles, endowed with different meanings in relation to its context.

She uses colored pencils as her favorite technique, although sometimes she also makes black and white comics. She is inspired by listening to her favorite music groups, and also seeing illustrations of other artists on Instagram. Aisha Franz, Juli Majer or Roberta Vázquez are some of her inspirations.

She has collaborated with various artists and collectives (Panoli, Tarot, Armadillo, Nimio, Dinamita Diminuta, etc.).

She loves to read the fanzines of her friends, those at self-publishing fairs like the Gutter or the Tenderete, and everything related to the world of comics.

Laura Endy es dibujante de cómics. Actualmente está estudiando tercero de Bellas Artes en la Universidad de Barcelona. Empezó a hacer fanzines en 2016, y desde entonces no ha parado.

Suele crear historias en las que plantea cuestiones como las emociones humanas o las relaciones interpersonales, acompañadas de dibujos que se mueven entre lo naïf, lo extraño y lo maravilloso. En sus cómics aparecen elementos como gotas de agua, plantas-mascota, estrellas fugaces o velas de colores, dotados de diferentes significados en relación a su contexto.

La técnica que más utiliza es el lápiz de color, aunque a veces también hace cómics en blanco y negro. Se inspira escuchando sus grupos de música favoritos, y también viendo ilustraciones de otras artistas en Instagram. Aisha Franz, Juli Majer o Roberta Vázquez son algunas de sus referentes.

Ha colaborado con diversos artistas y colectivos (Panoli, Tarot, Armadillo, Nimio, Dinamita Diminuta, etc).

Le encanta leer los fanzines de sus compañeras, las ferias de autoedición como el Gutter o el Tenderete, y todo lo relacionado con mundo del cómic.

← *Journeyman* cover
→ *Lowdown* zine cover
and single pages

Text & image courtesy of Laura Endy

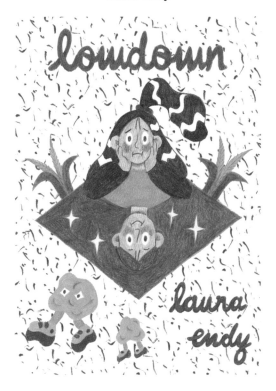

TOTAL INABILITY TO FUNCTION

LAURA ENDY

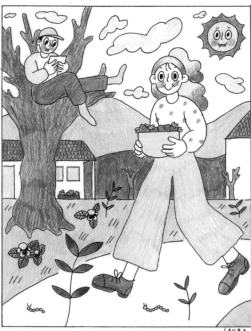

Total inability to function
cover and illustration

Single illustration before
and after coloring

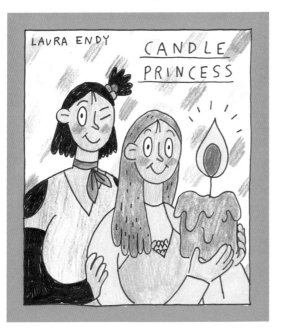

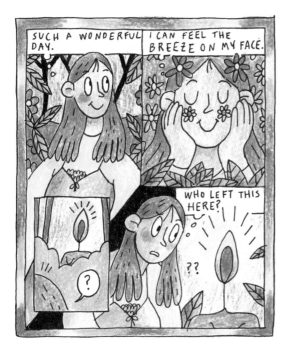

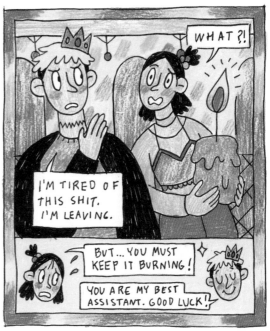

Candle Princess cover
and single pages

GRRRL ZINE FAIR

A Punk Attitude to Established Thought

LONDON

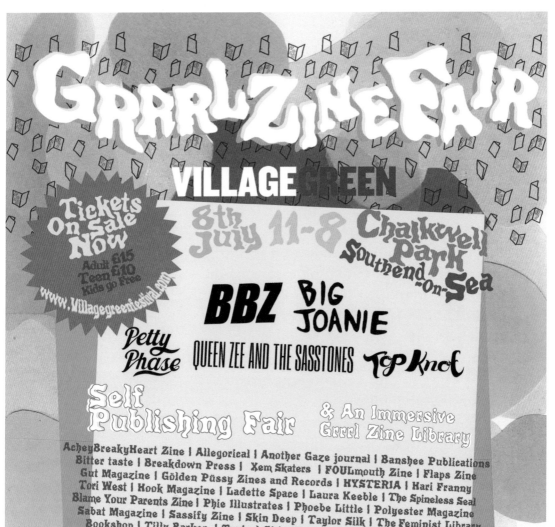

GRRRL ZINE FAIR

VILLAGE GREEN

Tickets On Sale Now
Adult £15
Teen £10
Kids go free
www.villagegreenfestival.com

8th July 11-8 Chalkwell Park Southend-on-Sea

BBZ BIG JOANIE

Petty Phase QUEEN ZEE AND THE SASSTONES Top Knot

Self Publishing Fair

& An Immersive Grrrl Zine Library

AcheyBreakyHeart Zine | Allegorical | Another Gaze journal | Banshee Publications
Bitter taste | Breakdown Press | Xem Skaters | FOULmouth Zine | Flaps Zine
Gut Magazine | Gölden Püssy Zines and Records | HYSTERIA | Hari Franny
Tori West | Hook Magazine | Ladette Space | Laura Keeble | The Spineless Seal
Blame Your Parents Zine | Phie Illustrates | Phoebe Little | Polyester Magazine
Sabat Magazine | Sassify Zine | Skin Deep | Taylor Silk | The Feminist Library
Bookshop | Tilly Barker | Typical Girls Magazine | Vagina Dentata Zine
Witchgirl Recordings | Ylva Oknelid and Leio Kirtly | Exchange Zine
Project Upcoming | Essex Girls Liberation Front

Workshops

Nail Transphobia
Guitar & Drums for beginners
Shadow Sistxrs Fight Club & Magic lessons
Portable Print Studio
Arts Sisterhood UK
Art therapy

Art Exhibtion

Curated by P.I.G. Studios

& Sculpture Garden

www.grrrlzinefair.com
@grrrlzinefair

Celebrating 1892-2017 125 SOUTHEND-ON-SEA

 ARTS COUNCIL ENGLAND

Supported using public funding by

Metal

Lu Williams creates artworks and arts events. Her works grow off the back of liminal spaces teetering between functionality and uselessness, collecting, mimicking and personalising. These ideas spawn from intersectional feminism, working class culture and a punk attitude to established thought.

Her practice of reconstructing ideas and objects, appropriating printed matter, reconditioning rituals of popular culture and re-contextualising craft labor takes various forms; be it casting road maintenance paraphernalia, documenting writing drawn into dirty white vans or photocopying, collaging, scanning and reprinting images and text-laying both digital and physical labor.

She has a multidisciplinary practice including sculpture, video, Djing, writing, zine making, workshop hosting, event planning, curation, community projects, lectures, craft, collaborating and collectivizing.

Grrrl Zine Fair is a continuous plan of event and project curation, workshops and self publishing. Williams uses the platform to showcase work created by women, trans, non-binary, LGBTQIA, people of color and people with disabilities (visible or non-visible) across publishing, contemporary art and music informed by intersectional feminism and Do It Yourself culture.

Lu Williams crea obras de arte y eventos artísticos. Sus obras crecen en la parte posterior de los espacios liminales oscilando entre funcionalidad e inutilidad, recogiendo, imitando y perso-nalizando. Estas ideas surgen del feminismo interseccional, la cultura de la clase trabajadora y una actitud punk hacia el pensamiento establecido.

Su práctica de reconstruir ideas y objetos, apropiarse de la materia impresa, reacondicionar los rituales de la cultura popular y volver a con-textualizar el trabajo artesanal adopta diversas formas; ya sea para montar la parafernalia del mantenimiento de carreteras, documentando la escritura dibujada en furgonetas blancas sucias o fotocopiando, haciendo *collages*, escaneado y reimprimiendo imágenes y colocando textos, tanto en trabajos digitales como físicos.

Tiene una práctica multidis-ciplinar que incluye escultura, video, *djing*, redacción, creación de fanzines, celebración de talleres, planificación de even-tos, comisariado, proyectos comunitarios, conferencias, manualidades, colaboración y colectivización.

Grrrl Zine Fair es un plan continuo de eventos y proyectos de comisariado, talleres y autoedición. Williams utiliza esta plataforma para mostrar el trabajo creado por mujeres, transexuales, no binarias, LGBTQIA, personas de color y personas con discapacidades (visibles o no) en publicaciones, arte contemporáneo y música fundamentada por el feminismo intersectorial y la cultura del 'hazlo tú mismo'.

Text & image courtesy of Lu Williams

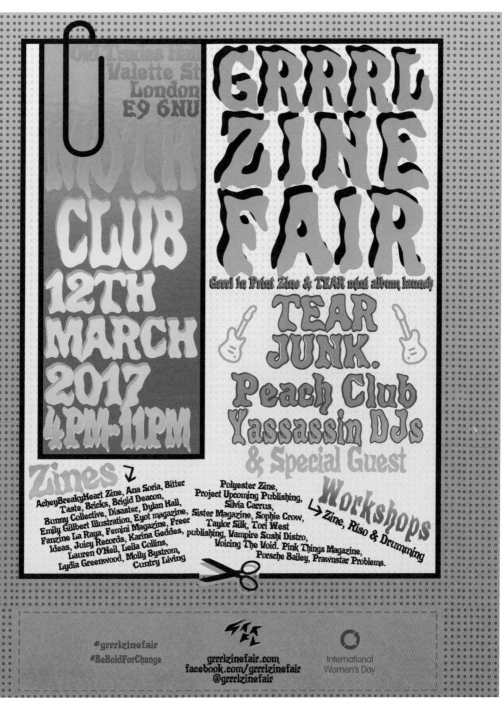

← Lu Williams *Grrrl Zine Fair* Stage Poster for Village Green Festival 2017 Southend Essex

↑ Lu Williams *Grrrl Zine Fair* poster for International Women's Day 2017 Moth Club London

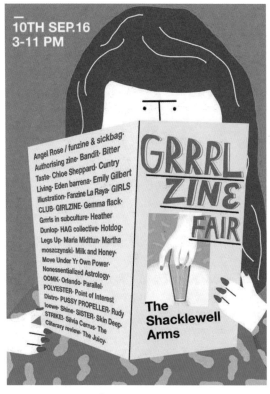

1

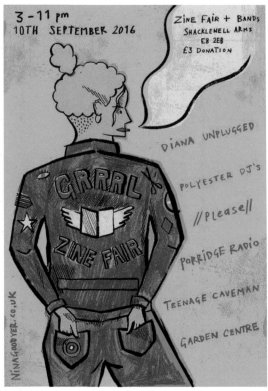

2

3

4

1-2 Elena Eper Zines & Nina Goodyer Bands
posters for GZF for The Shaklewell Arms
3-4 *Grrrl In Print* Issue 1
Ph: Specialist Subject Records
5-8 Feminist Christmas Fair 2017 at R.A.W

Labs, Bow Arts by GZF & other independent
publishers. Ph: Orlando Myxx
9-10 Tear at GZF at Moth Club. Ph: Meg Lavender
11 Jender Anomie at GZF at Moth Club
Ph: Meg Lavender

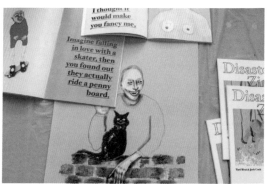

5 Disaster Zine

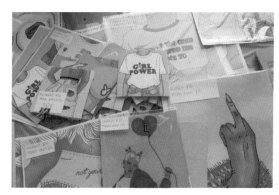

6 Sophie Rose Brampton

7

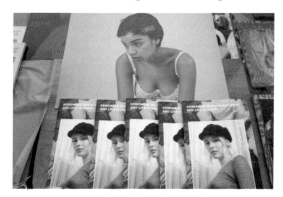

8 Chloe Sheppard

9

10

11

BÀRBARA ALCA

The Fanzine as a Means of Emotional Liberation

P. MALLORCA → BARCELONA

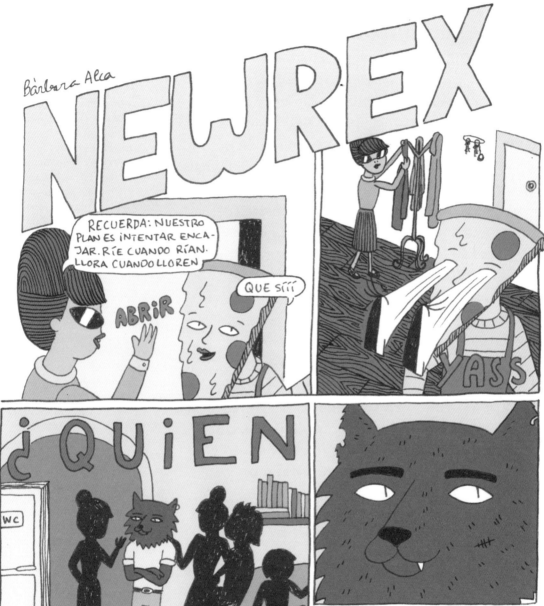

Bàrbara Alca (Mallorca, 1990), is a graphic designer, and author of comics. After training in graphic design, she decided to move away as far as possible from the computer, which she currently only uses to color her comics and layout her fanzines. In them she narrates the experiences of some key characters: Pizzachica, a girl with a pizza face; Perra 2000, a dog lover of the new millennium and a lover of the outfits of the golden age of Cristina Aguilera; Princess Bridget, the vampire best friend of Pizzachica whose cynicism makes her the most rational character of the group; Papanazzi, a Nazi elf who will never call you again; and Tommy Wolf, a very bad werewolf but with a huge heart.

Bàrbara uses the fanzine as a means to express her own experiences and to leave, in terms of humor, some emotional quagmire, since all the characters and the vast majority of events are based on real people and situations.

The author always carries her notebooks and her case full of Rotrings and drawing pencils in order to draw wherever an idea arises.

Bàrbara Alca (Mallorca, 1990), es una diseñadora gráfica, ilustradora y autora de cómic. Después de formarse en diseño gráfico decidió alejarse en la medida de lo posible del ordenador, que actualmente utiliza para colorear sus historietas y maquetar sus fanzines. En ellos narra las vivencias de unos personajes clave: Pizzachica, una chica con cara de pizza; Perra 2000, una perra amante del nuevo milenio y de los outfits de la época dorada de Cristina Aguilera; Princess Bridget, la vampira mejor amiga de Pizzachica cuyo cinismo hace de ella el personaje más racional del grupo; Papanazzi, un elfo nazi empotrador que jamás te volverá a llamar; y Lobo Tommy, Un hombre lobo muy macarra pero con un enorme corazón.

Bàrbara utiliza el fanzine como medio para expresar sus propias experiencias y para salir, en clave de humor, de algún que otro atolladero emocional, ya que todos los personajes y la gran mayoría de sucesos están basados en personas y situaciones reales.

La autora siempre lleva a cuestas su cuadernos y estuche lleno de Rotrings y lápices para dibujar donde le surja una idea.

Text & image courtesy of Bàrbara Alca

← *Newrex* cover
→ *Newrex* single pages

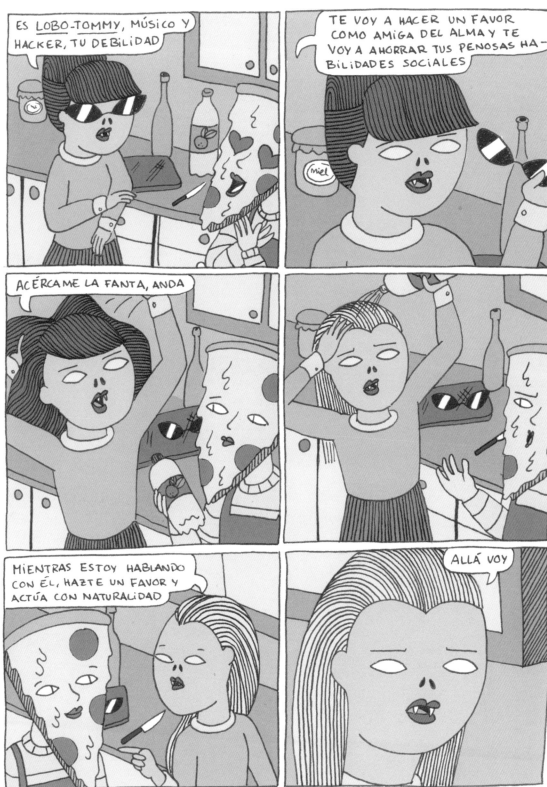

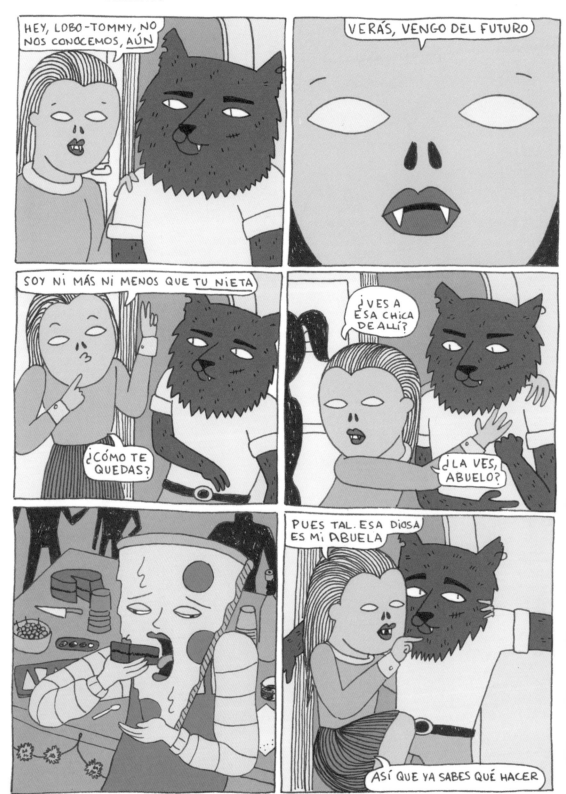

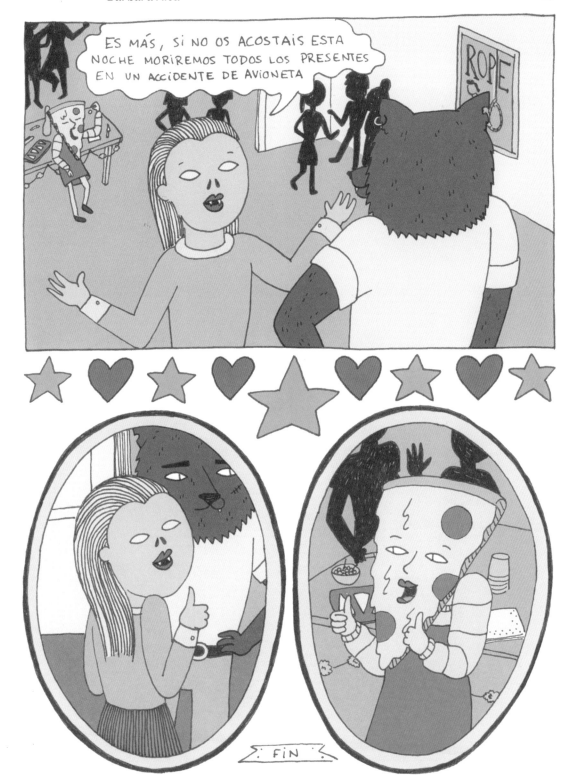

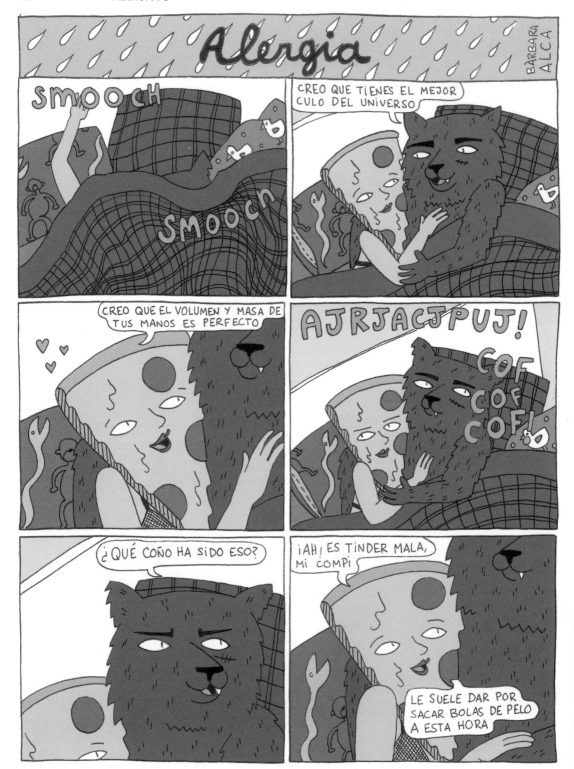

Alergia single pages

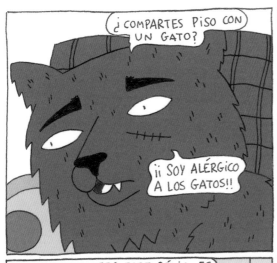

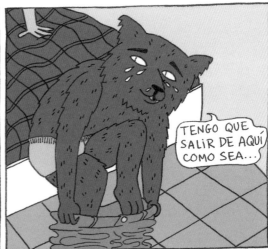

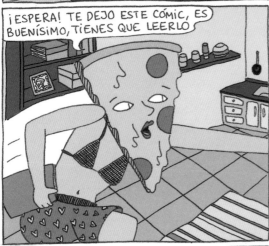

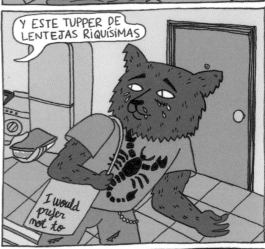

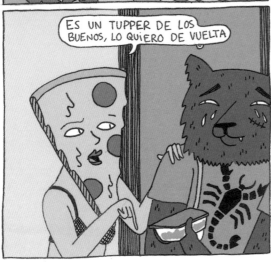

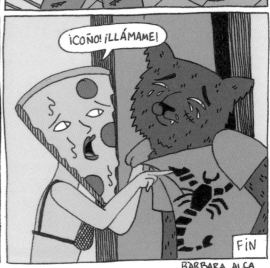

RIVISTA FRUTE

Inclusivity Through New Female Identities

UDINE

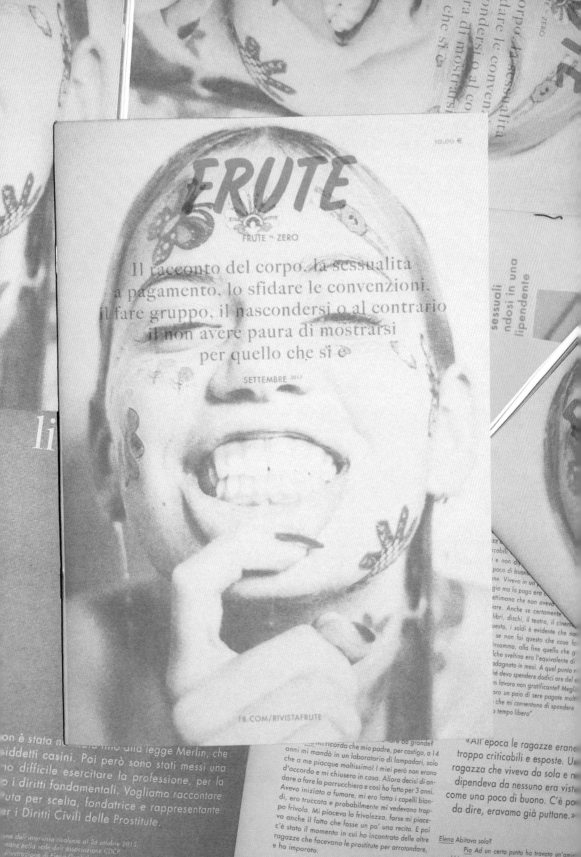

Frute is an independent magazine that deals with themes concerning intersectional feminism, gender fluidity, different sexualities, sexual boundaries, inclusion, prevention of discrimination and a critical take on monogamy and heteronormativity in family structures.

The broader framework of *Frute* wants to address self-knowledge and acceptance, together with the concept of a new female identity. The goal is to make use of independent publishing as a tool to represent a movement promoting a cultural development in which all genders and sexual orientations are treated as valuable, in which they are embraced and building towards inclusivity.

Who's behind *Frute*? The project started as a MA thesis project in Design for Publishing by Cecilia Cappelli. But the network around it is much bigger: three photographers, three illustrators, a poetess, and two journalists collaborated for the first issue, which was printed in risograph on pink paper, in a small amount of copies.

In the present moment *Frute* has a lot of collaborators and supporters, all around the gender spectrum– in fact the project isn't just a magazine but also a community who understand and support what *Frute* represent, and the second issue is almost ready.

Frute es una revista independiente que aborda temas relacionados con el feminismo interseccional, la fluidez de género, las diferentes sexualidades, las fronteras sexuales, la inclusión, la prevención de la discriminación y una visión crítica de la monogamia y la heteronormatividad en las estructuras familiares.

El marco más amplio de *Frute* quiere abordar el autoconocimiento y la aceptación, junto con el concepto de una nueva identidad femenina. El objetivo es hacer uso de la publicación independiente como una herramienta para representar un movimiento que promueve un desarrollo cultural en el que todos los géneros y orientaciones sexuales son tratados como valiosos, en el que se los acoge y se construye un camino hacia la inclusión. ¿Quién está detrás de *Frute*?

El proyecto comenzó como el proyecto de tesis de un máster en Diseño Editorial de Cecilia Cappelli. Pero la red a su alrededor es mucho más grande: tres fotógrafos, tres ilustradores, una poetisa y dos periodistas colaboraron en la primera edición, que se imprimió en risografía en papel rosa, en una pequeña cantidad de copias.

Actualmente, *Frute* tiene muchos colaboradores y seguidores en todo el abanico de géneros; de hecho, el proyecto no es solo una revista, sino también una comunidad que comprende y respalda lo que representa *Frute*. Y la segunda edición está casi lista.

← *Rivista Frute* Issue 0
→ Merchandising: sticker, postcard and totebag

Text & image courtesy of Cecilia Cappelli

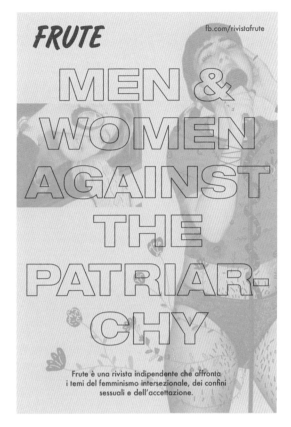

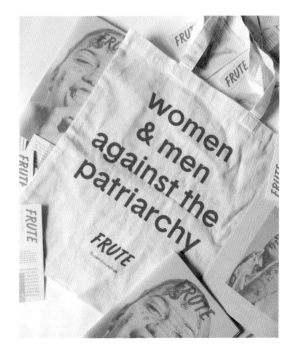

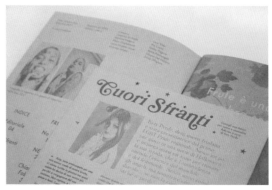
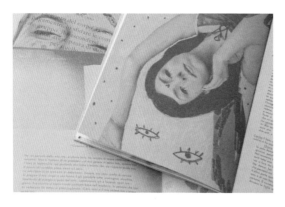

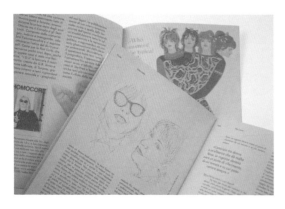
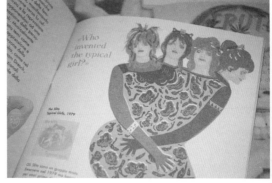

↑ *Rivista Frute* Issue 0
→ Detail of a single page

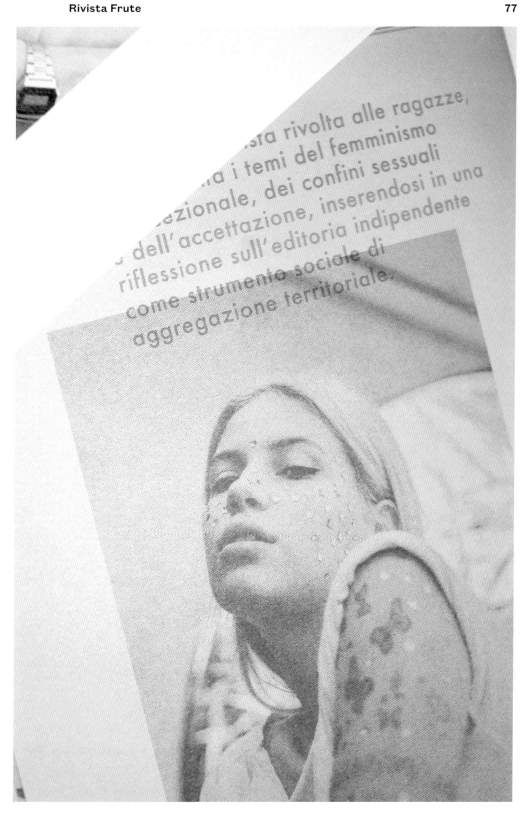

...sta rivolta alle ragazze,
...a i temi del femminismo
...ezionale, dei confini sessuali
...e dell' accettazione, inserendosi in una
riflessione sull' editoria indipendente
come strumento sociale di
aggregazione territoriale.

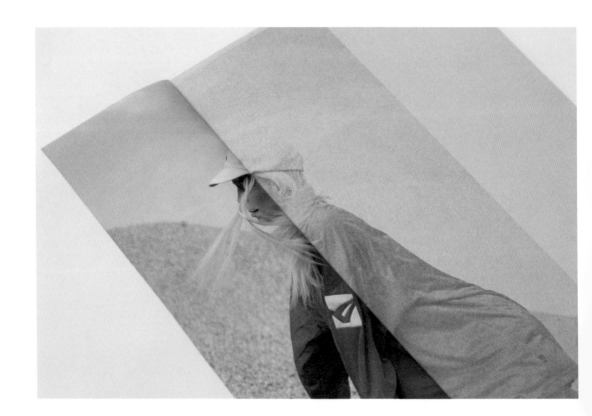

↑ Detail of a double-page spread
→ Full color double-page spread

Female Talent to Achieve Concrete Change

Sister is a bi-annual, independent and feminist publication. Founded in 2012 by Beccy Hill whilst studying at university, they have just released their eighth print issue. Inspired by 90s Riot Grrrl zines and feminist literature, Beccy wanted to bring these ideas up to date and to the mainstream. She wanted to make a magazine for young people which married fashion and feminism, as at the time she didn't believe there was anything out there doing so.

Sister's core value is that all issues are women's issues, and that by providing a platform for them to be discussed, concrete change can be achieved. Events including parties, panel discussions and zine fairs are the beating heart of *Sister*.

By providing a space for their community, who mainly interact online, to meet up and hang out in real life is an integral part of what they do.

Sister es una publicación feminista semestral independiente. Fundada en 2012 por Beccy Hill mientras estudiaba en la universidad, la revista acaba de publicar su octava edición impresa. Inspirándose en los zines de los 90 del movimiento Riot Grrrl y en la literatura feminista, Beccy quería actualizar esas ideas y darlas a conocer al gran público. Su objetivo era hacer una revista para jóvenes que combinara moda y feminismo, puesto que, por aquel entonces, no creía que hubiera nadie más que se dedicara a hacer eso.

La filosofía de *Sister* reside en la idea de que todas las cuestiones están relacionadas con la mujer, y de que es posible conseguir cambios concretos ofreciendo una plataforma en la que dichas cuestiones puedan discutirse.

Eventos como fiestas, debates entre expertos y ferias de fanzines forman parte importante del corazón de *Sister*, una de cuyas labores fundamentales consiste en ofrecer un espacio para su comunidad, que suele interactuar *online*, de forma que sus miembros también puedan conectar en la vida real.

← Musician Girli shot by Hannah Smith and styled by Beccy Hill for *The Swag Issue*

Text & image courtesy of Beccy Hill

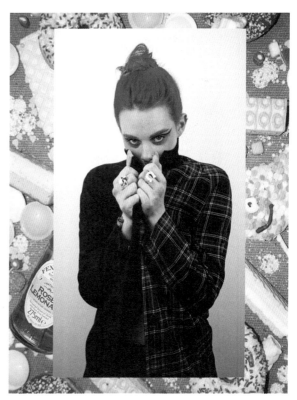

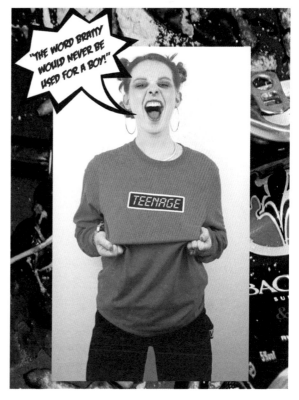

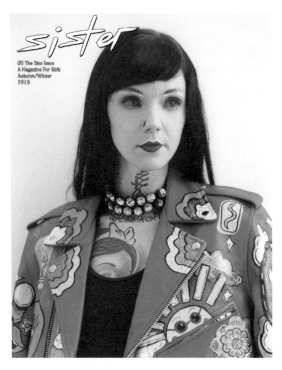

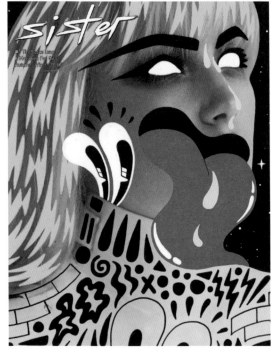

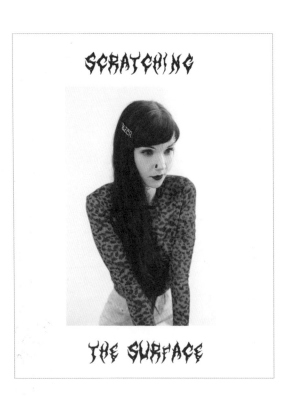

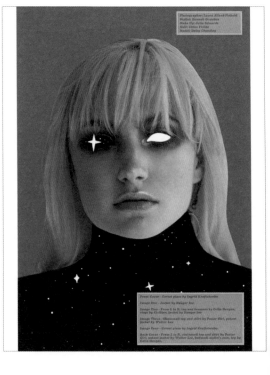

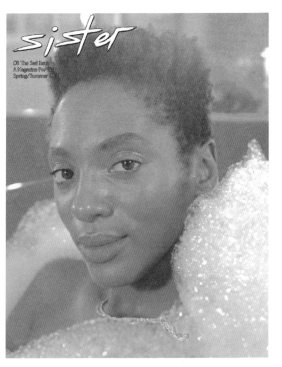

sister

C8 The 3rd Issue
A Magazine For Girls
Spring/Summer 2018

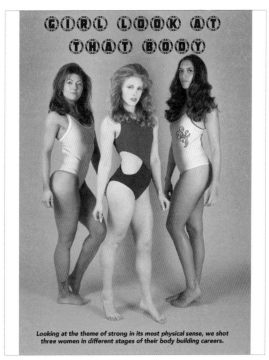

GIRL LOOK AT THAT BODY

Looking at the theme of strong in its most physical sense, we shot three women in different stages of their body building careers.

I LOOK BETTER ONLINE

ROSIE FAYE ELLIS MEETS ARTIST SOPHIE ROSE BRAMPTON

If you haven't discovered Sophie Rose Brampton's work yet, the artist herself describes it as "quirky, bold, cute and colourful pictures of girls." She also believes that without Instagram she "probably wouldn't have created half the things I have today," and you definitely can't mistake the influence social media has on her work. Saying that, her initial design process stems from visuals, graphics or photography that I've spotted on Instagram or Pinterest, she then goes about manipulating something extremely current in her very own stand our style. For example, one of her most recognised pieces is her recreation of Solange's 'A Seat At The Table' album cover. "She's an amazing visual artist and that album cover was one that stood out last year. I was just dying to recreate it."

Other girls are created purely from her imagination, bursting with personality and confidence. They often sport catchy slogans placed across boobs and bums, declaring things like 'I Look Better Online' and 'Not Your Babygurl' making for extremely regram worthy catchphrases. Looking closer, Brampton shows women being naturally sexual but always exuberating power in their own skin. She explains how this is a conscious theme throughout her work and is keen to slash any slut shaming due to her own past experiences. "I've always been intrigued by the idea that women being sexual is negative in our society or a woman loving herself makes her snuck up. Some people just can't handle the fact that a woman can be

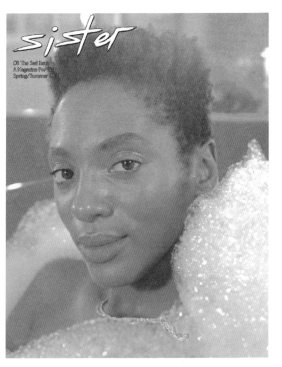
Check out our exclusive Sister gal by Sophie!

sexual, outspoken and strong and that is not my problem. I hope my work reflects that."

"Fashion, pop culture, 90's, trash and bright colours" are all listed as her biggest influences, so it's no wonder that nostalgic watch brand Baby-G enlisted Brampton to produce a three piece series named #PrettyToughGirls to go alongside their collaboration with Casio. It featured colourful girls sporting even brighter Baby-G's in true Brampton style. "I feel like the minimalism and monochrome interior trend has drained the colour from some people's lives, and I want to give back that colour through my art. I love creating work that is bright, bold and different, with perhaps a message that is either shocking at first or just plain sassy as luck."

Brampton's girls are confident, colourful and most of all strong, so what does that word personally mean to her? "Focusing on my goals as an artist keeps me motivated and strong. It sounds selfish but sometimes you need to put yourself first to keep your mind in a good place where you can be strong and confident in yourself."

If you'd like to keep up to date with Sophie Rose Brampton and her vibrant girls, then head to @sophierosebrampton on Instagram.

27

HOLD ME CLOSER

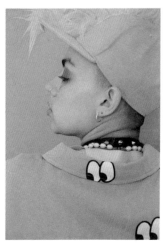

TINY DANCER

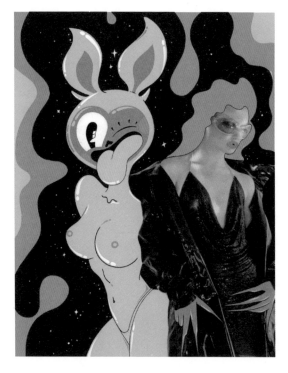

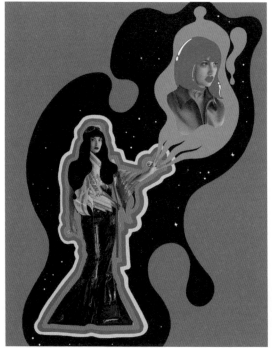

↑→ Hattie Stewart
illustrations for *The Space
Issue*. Photography by Laura
Allard-Fleischl, styling by
Hannah Grunden, make up
by Julia Edwards, hair by
Chloe Frieda

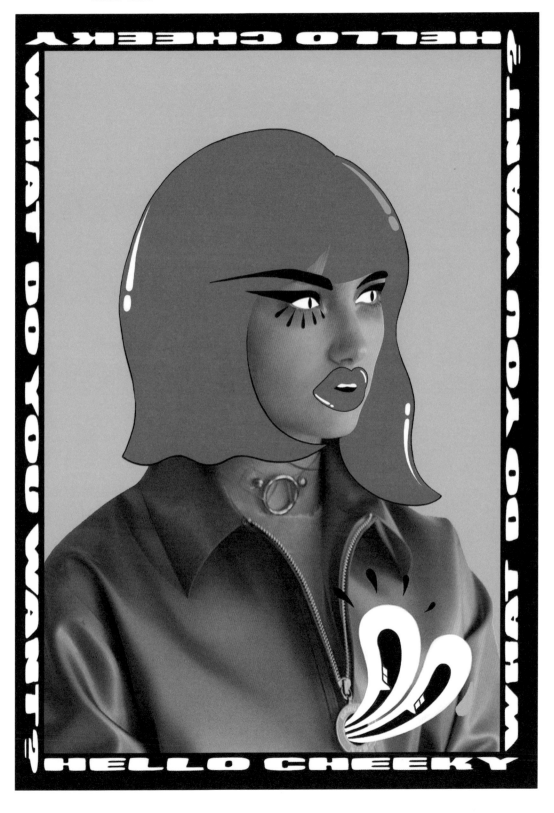

ALBA FEITO

Intimate Nightmares and Social Anxieties

ASTURIAS → BARCELONA

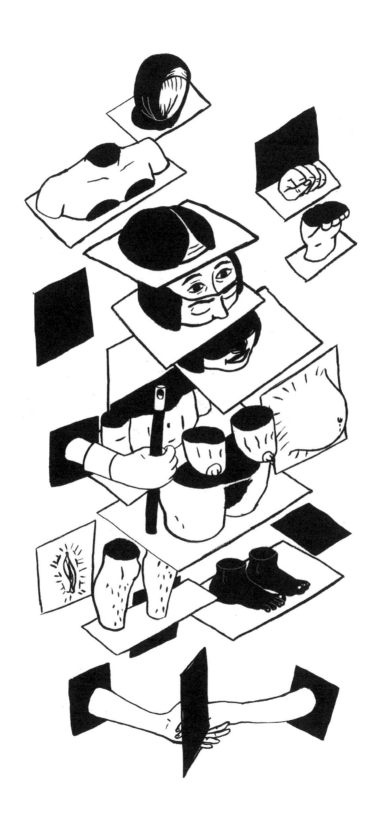

'In the illustrations of Alba Feito, an Asturian DIY artist and activist living in Barcelona, there is a surrealist wish to formulate a graphic synopsis of our most intimate nightmares and social anxieties in that human, too human, body.' Ana Llurba, for the *Barcelonès* magazine.

Alba Feito has been co-editor of the Horriblemente Humano fanzines publishing house (2013–2016), where she got into it through love to practise self-publishing.

She has collaborated with drawings in numerous collective fanzines: *Bulbasaur #7* (2017), *Cultura de la Violación* (Antipersona, 2017), *Nenazas* (Horriblemente Humano, 2016), *Los Archivos de Beauvoir* (Hello Ediciones, 2016), *Tetas* (Ladyfest, 2016), *These Things Take Time* (Morboso y Mohoso, 2015), *Publicación Mutante* (compilation of Jornadas Mutantes, 2014), and individual fanzines: *Encarnaciones* (Hacer Sitio, 2016) and *La Casa Menguante* (Bombas para Desayunar, 2016).

Feito has been part of community projects (FLIA, Jornadas Mutantes and Imprenta Col·lectiva de Can Batlló), and in several collective exhibitions on body and gender such as *Herselves* (Blueproject Foundation, 2016) and *Hacer Sitio* (C.S.O La Usurpada, 2016).

She belongs to the feminist art collective Nenazas, her most complete center of sorority.

Text & image courtesy of Alba Feito

'En las ilustraciones de Alba Feito, artista y activista DIY asturiana residente en Barcelona, se evidencia una voluntad surrealista para formular una sinopsis gráfica de nuestras más íntimas pesadillas y ansiedades sociales en eso tan humano, demasiado humano como es el cuerpo.' Ana Llurba, para la revista *Barcelonès*.

Alba Feito ha sido coeditora de la editorial de fanzines Horriblemente Humano (2013–2016), en la que entra a través del amor a la práctica de la autopublicación.

Ha colaborado con dibujos en numerosos fanzines colectivos: *Bulbasaur #7* (2017), *Cultura de la violación* (Antipersona, 2017), *Nenazas* (Horriblemente Humano, 2016), *Los Archivos de Beauvoir* (Hola Ediciones, 2016), *Tetas* (Ladyfest, 2016), *These things take time* (Morboso y Mohoso, 2015), *Publicación Mutante* (compilación sobre Jornadas Mutantes, 2014), e individuales: *Encarnaciones* (Hacer sitio, 2016) o *La casa menguante* (Bombas para desayunar, 2016).

Feito ha formado parte de proyectos comunitarios (FLIA, Jornadas Mutantes e Imprenta col·lectiva de Can Batlló), y en varias exposiciones colectivas sobre cuerpo y género, como *Herselves* (Blueproject Foundation, 2016) y *Hacer sitio* (C.S.O La usurpada, 2016).

Pertenece al colectivo artístico feminista Nenazas, su eje de soraridad más completo

← Detail of *Agenda Can Batlló*
1 *Bulbasaur* zine
2 *Molly Nilsson* zine
3 *Los Archivos de Beauvoir* zi

1

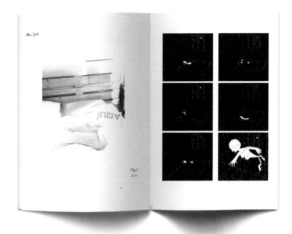

2

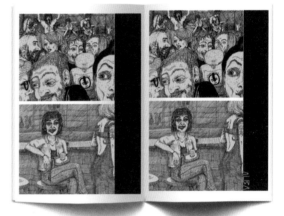

3

4

FANZINE

por y para Ladyfest Barcelona 2016

TETAS

5

6

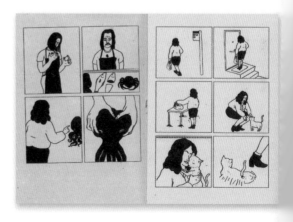

7

8

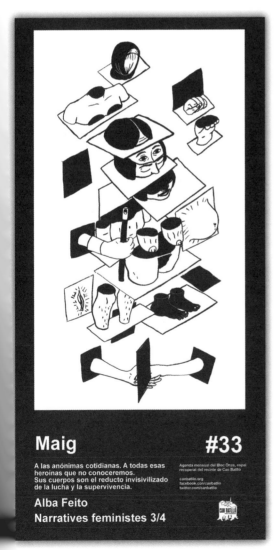

Maig #33

A las anónimas cotidianas. A todas esas heroínas que no conoceremos. Sus cuerpos son el reducto invisibilizado de la lucha y la supervivencia.

Agenda mensual del Bloc Onze, espai recuperat del recinte de Can Batlló

canbatllo.org
facebook.com/canbatllo
twitter.com/canbatllo

**Alba Feito
Narratives feministes 3/4**

9

ASHLEY RONNING

Low-waste Processes and Creative Freedom

MELBOURNE

Ashley Ronning is an illustrator based in Melbourne, Australia. Her creative endeavors began when she was four, and cut her own hair to complete a picture of a pony. After studying graphic design at Shillington College, Ashley found her way into freelance design, set dressing and prop making for film, and now spends her time in her Brunswick studio as an illustrator and risograph printer.

Ashley also runs a risograph publishing project called Helio Press. She created Helio to publish the work of other artists, to connect them the incredible medium of risograph while providing the guidance and support to make their publication the best it can be. In 2017 Helio Press expanded into a printing service to allow more people access to risograph printing.

Risograph printing is an incredibly important medium to Ashley in her personal work, as she values the ownership and control of seeing through the entire print making process in the same studio where she creates her work. This also allows a lot of freedom with trial and error as well as experimentation with the process. As an artist committed to sustainability in her process, risograph also provides an environmentally sound and low-waste solution to print editions and self publishing in her artistic practice.

Ashley Ronning es una ilustradora que vive en Melbourne, Australia. Sus esfuerzos creativos comenzaron cuando tenía cuatro años y se cortó su propio pelo para completar una imagen de un poni. Después de estudiar diseño gráfico en Shillington College, Ashley se abrió camino en el diseño *freelance*, dedicándose al vestuario y al atrezo para el cine, y ahora invierte su tiempo en su estudio de Brunswick como ilustradora e impresora Riso.

Ashley también dirige un proyecto editorial de risografía llamado Helio Press. Fundó Helio para publicar el trabajo de otros artistas; para conectarlos con el increíble medio de la risografía y, al mismo tiempo, brindar la orientación y el apoyo necesarios para que sus publicaciones sean las mejores posibles. En 2017, Helio Press se amplió a un servicio de impresión para permitir que más personas accedan a la impresión Riso.

La impresión Riso es un medio increíblemente importante para Ashley en su trabajo personal, ya que valora la posesión y el control de ver a través de todo el proceso de impresión en el mismo estudio donde crea su trabajo. Esto también le permite tener mucha libertad con pruebas y errores, así como a experimentar con el proceso. Como artista comprometida con la sostenibilidad en su proceso, el riso también proporciona una solución ecológica y de bajos residuos para imprimir ediciones y autoediciones en su práctica artística.

Text & image courtesy of Ashley Ronning

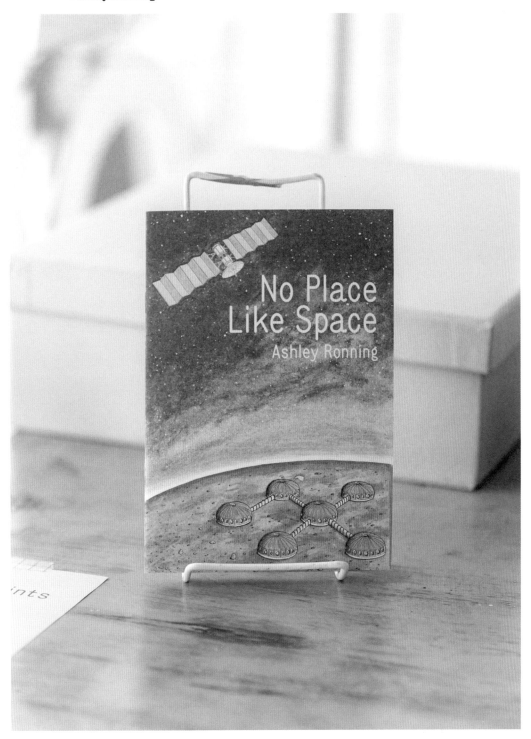

← Ashley Ronning in her studio
↑ *No Place Like Space* zine cover
Ph: Tatanja Ross

Planting Guide for Autumn zine
cover and double-page spread

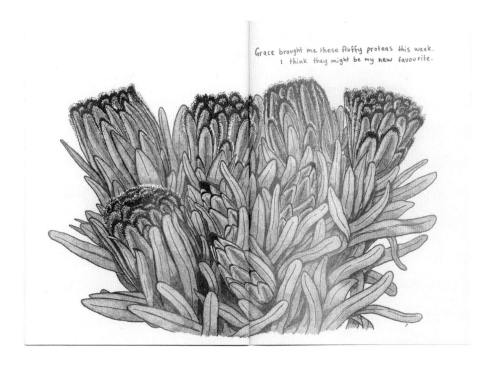

Grace brought me these fluffy proteas this week.
I think they might be my new favourite.

Grandma (mum's mum) built her garden from
scratch around her house on her farm with
grandfather and won a bunch of awards.

Pop (dad's dad) grows the most
incredible fruit & veggies in
his backyard and has won
a bunch of awards.

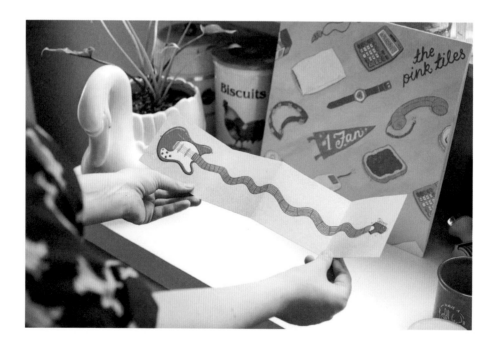

The Longest Wobbliest
Silliest Guitar, a foldable
zine cover and interior
Ph: Tatanja Ross

Welcome to my studio zine
cover and double-page spread

ELISA RIERA

Reality from the Absurd in a Tragicomic Tone

BARCELONA ⬌ SHANGHAI

Elisa Riera studied graphic design and illustration, but for years she has been dedicated to fashion consultancy and works divided between Asia and Europe.

As a personal project, she narrates and illustrates a cartoon diary on Instagram, and the topics she deals with are so varied that they range from her love affairs, to experiences in China, to advice from her mother.

With a tragicomic tone, Elisa is interested in transmitting her metafictional reality from a point of view of the absurd, laughing at herself, at everything, and at everyone. She uses her iPad Pro and takes advantage of her time by drawing at airports and during her roundtrips to Shanghai or Beijing.

Elisa Riera estudió diseño gráfico e ilustración pero hace años que se dedica a la consultoría d moda, y trabaja a caballo entre Asia y Europa.

Como proyecto personal, narra e ilustra un diario a viñetas en Instagram, y los temas que trata son tan variopintos que van desde sus amoríos, experiencias en China o consejos de su madre.

Con un tono tragicocómico, a Elisa lo que le interesa es transmitir su realidad metaficcionada desde un punto de vista de lo absurdo, riéndose de ella, de todo y de todos. Como soporte utiliza su iPad Pro, y aprovecha para dibujar en los aeropuertos y durante sus viajes de ida y vuelta a Shangha o Beijing.

Text & image courtesy of Elisa Riera

← Self-portrait illustration
→ Elisa Riera's vignettes on her Instagram feed

#ilustracion #dibujo #comic #sketch #drawing
#doodle #ipadpro #character #metaficcion
#webcomic #viñeta #feminismo #artwork
#feminismoilustrado #work #womenwithpencils
#elfuturoesbrillante #elevator #ascensor
#meetingroom #女权主义者

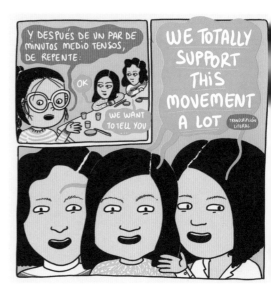

#illustration #ilustracion #cartoon #dibujo
#comic #comics #sketch #drawing #doodle
#ipadpro #character #metaficcion #webcomic
#viñeta #feminismo #feminismoilustrado #busy
#tryyourbest #elfuturoesbrillante #support
#女权主义者

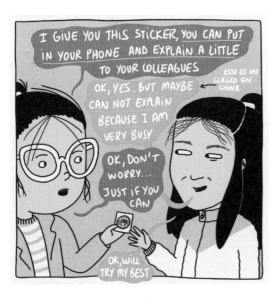

#illustration #ilustracion #cartoon #dibujo
#comic #comics #sketch #drawing #doodle
#ipadpro #character #metaficcion #webcomic
#viñeta #feminismo #feminismoilustrado #busy
#tryyourbest #elfuturoesbrillante #女权主义者

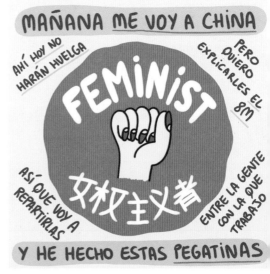

#illustration #ilustracion #cartoon #dibujo
#comic #comics #sketch #drawing #comics
#doodle #ipadpro #metaficcion #webcomic
#viñeta #feminismo #feminismoilustrado
#nosotrasparamos #8M #internationalwomensday
#女权主义者

#illustration #ilustracion #cartoon #dibujo
#comic #comics #sketch #drawing #comics
#doodle #ipadpro #metaficcion #webcomic
#viñeta #taxi #sí

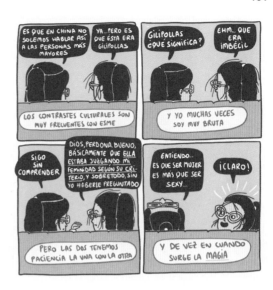

#illustration #ilustracion #cartoon #dibujo
#comic #comics #sketch #drawing #comics
#doodle #ipadpro#metaficcion #webcomic
#viñeta #feminismos #magia #taxi

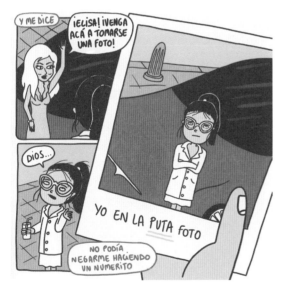

#illustration #ilustracion #cartoon #dibujo
#comic #comics #sketch #drawing #comics
#doodle #ipadpro #metaficcion #webcomic
#polaroid

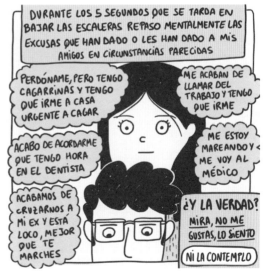

#illustration #ilustracion #cartoon #dibujo
#comic #comics #sketch #drawing #comics
#doodle #ipadpro #metaficcion#webcomic
#tinder #negroni #no#excusas

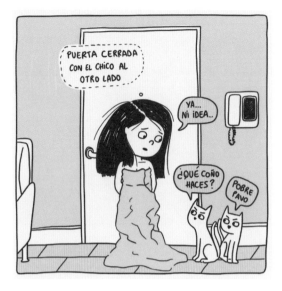

#illustration #ilustracion #cartoon #dibujo
#comic #comics #sketch #drawing #comics
#doodle #ipadpro #metaficcion #webcomic
#tinder #cats #cat

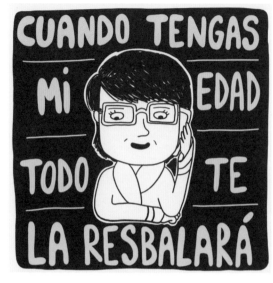

#illustration #ilustracion #cartoon #dibujo
#comic #comics #sketch #drawing #comics
#doodle #ipadpro #metaficcion #webcomic
#lettering #tipografia #telefono #mama
#truefact

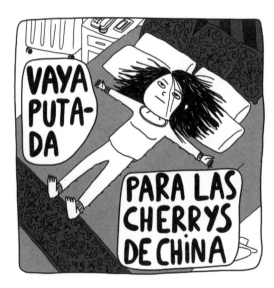

#illustration #ilustracion #cartoon #dibujo
#comic #drawing #comics #doodle #ipadpro
#metaficcion

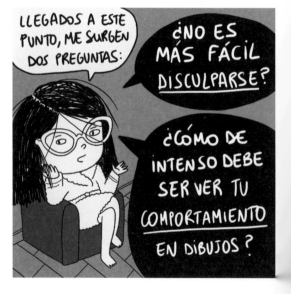

#illustration #ilustracion #cartoon #dibujo
#comic#drawing #comics #doodle #savoirfaire
#ipadpro

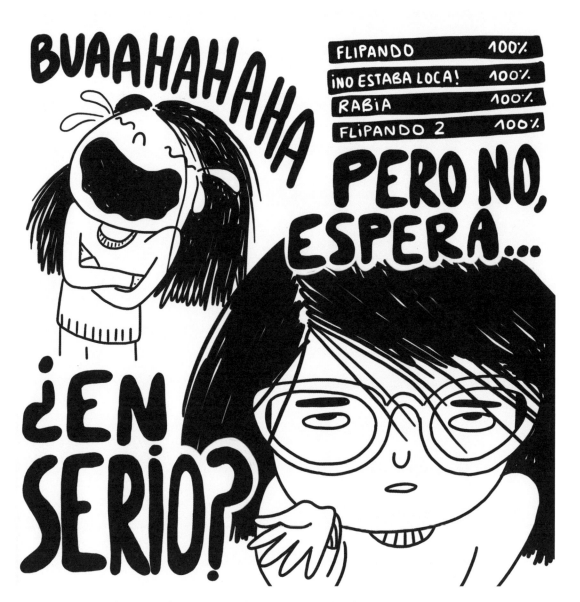

#illustration #ilustracion #cartoon #dibujo
#comic #comics #doodle #savoirfaire #really
#seriously #ipadpro

MARLENE KRAUSE

Atypical Comics and Multiple Graphic Narrations

WANNE–EICKEL → HAMBURG
→ BARCELONA

Marlene Krause was born in 1984 in Wanne-Eickel, Germany. She studied illustration at the University of Applied Arts in Hamburg, where she published the comic magazine Two Fast Colour from 2007 to 2012.

In 2013 she published her first graphic novel 'À un autre endroit' with the L'Association publishing house in France

Since 2012 she has lived and worked in Barcelona. She has participated in magazines such as Orang, Kuš!, Strapazin, Kuti Kuti, and Colibrí, among others. Krause has shown her work in multiple exhibitions:

2017: *Wunderkinder*. Chic@s maravilla (with Roberta Vázquez), Molar bookshop, Madrid, Spain.

2016: *Amb un gelat a la mà davant el fàstic*. Sant Andreu Contemporani, Barcelona, Spain. *Another shade of Beton*. Zuständige Behörde gallery, Leipzig, Germany. Ungles de Neon. Centre Cultural La Bòbila, L'Hospitalet de Llobregat, Spain.

2015: *Teme a los lugares sin alma*. Fatbottom graphic bookshop, Barcelona, Spain. *Fürchte die Orte ohne Seele*. Fumetto Comic Festival, Luzern, Switzerland.

2013: *Ungeeignetes Habitat*. Comic Festival Hamburg, Germany. *Niemand ist frei*. Alte Mitte gallery, Essen, Germany. *Niemand ist frei*. Frappant gallery, Hamburg, Germany.

Text & image courtesy of Marlene Krause

Marlene Krause nace en 1984 en Wanne-Eickel, Alemania. Estudia ilustración en la Universidad de Artes Aplicadas de Hamburg, donde publica la revista de cómics Two Fast Colour de 2007 a 2012.

En 2013 se publica su primera novela gráfica 'À un autre endroit' con la editorial L'Association en Francia.

Desde 2012 vive y trabaja en Barcelona. Ha participado en revistas como Orang, Kuš!, Strapazin, Kuti Kuti y Colibrí, entre otras. Krause ha mostrado su trabajo en múltiples exposiciones:

2017: *Wunderkinder*. Chic@s maravilla (junto a Roberta Vázquez), Molar bookshop, Madrid, España.

2016: *Amb un gelat a la mà davant el fàstic*. Sant Andreu Contemporani, Barcelona, España. *Another shade of Beton*. Zuständige Behörde gallery, Leipzig, Alemania. *Ungles de Neon*. Centre Cultural La Bòbila, L'Hospitalet de Llobregat, España.

2015: *Teme a los lugares sin alma*. Fatbottom graphic bookshop, Barcelona, España. *Fürchte die Orte ohne Seele*. Fumetto comic festival, Luzern, Suiza.

2013: *Ungeeignetes Habitat*. Comic Festival Hamburg, Alemania. *Niemand ist frei*. Alte Mitte gallery, Essen, Alemania. *Niemand ist frei*. Frappant gallery, Hamburg, Alemania.

← *Dancing the sick baby blues*, Illustration for Armadillo fanzine
1-2 *Old Skin* comic pages
4-4 *Zombi comic* pages

1

2

3

4

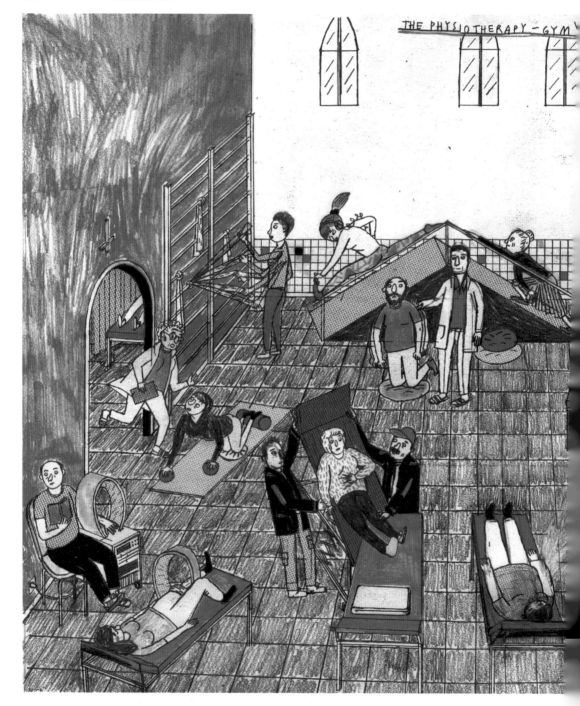

↑ *The Physiotherapy Gym,*
Illustration for Kuš Comics
→ *Kombucha* comic cover

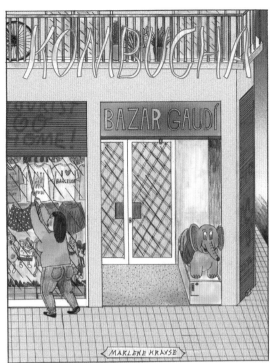

GEMMA DAVIS

The Power of a Zine as a Culture of Repair

MELBOURNE

Gemma Davis is an artist and designer based in Melbourne, Australia. Her process is steeped in design methadology, with a research based approach to art making. She is fascinated with the concept of mediating objects, art that doesn't simply point out an issue, but begins to discuss possible solutions.

The featured zine was her first dip into the world of zine making. In response to her research into the history and cultural significance of the zine *Space Invasion; A Piece of Cake* is intended as a mediating object itself. It appears a guide in how to 'bake' a zine, yet reveals that which a zine makes: embodied communities, a voice for the marginalised and a recoding of value in respect to materiality. Essentially it is intended as a toolkit to understanding the power of a zine as a culture of repair, and a guide to using it as one.

Zines as informal publications are essentially modes of space invasion, a vessel for distributing ideas and subculture — bite sized. A6 in size and printed on pink copy paper via a home printer, this zine is hand stitched together. A card cover the crispy crust for its warm gooey contents. It invites you to have your cake and eat it!

Gemma Davis es una artista y diseñadora con sede en Melbourne, Australia. Su proceso está inmerso en la metodología del diseño, con un enfoque basado en la investigación para la creación artística. Le fascina el concepto de objetos mediadores, arte que no solo señala un problema, sino que comienza a discutir posibles soluciones.

El fanzine presentado fue su primer chapuzón en el mundo de la fabricación de zines. En respuesta a su investigación sobre la historia y el significado cultural del fanzine *Space Invasion; A Piece of Cake* se entiende como un objeto mediador.

Parece una guía sobre cómo 'cocinar' un zine, pero revela lo que se consigue con ella: comunidades personificadas, una voz para los marginados y una recodificación de valor con respecto a la materialidad. Esencialmente, pretende ser un conjunto de herramientas para comprender el poder del zine como cultura de reparación y una guía para usarla como tal.

Los fanzines, como publicaciones informales, son fundamentalmente modos de invasión espacial, un recipiente para la distribución de ideas y de la subcultura en pequeñas dosis. En tamaño A6 e impreso en papel de copia rosa utilizando una impresora doméstica, este zine está cosido a mano. La crujiente corteza que tiene como portada alberga un contenido caliente y viscoso. ¡Te invita a cogerlo y comértelo!

Text & image courtesy of Gemma Davis

← Detail of *Space Invasion.*
A piece of cake
→ Cover and double-page spread

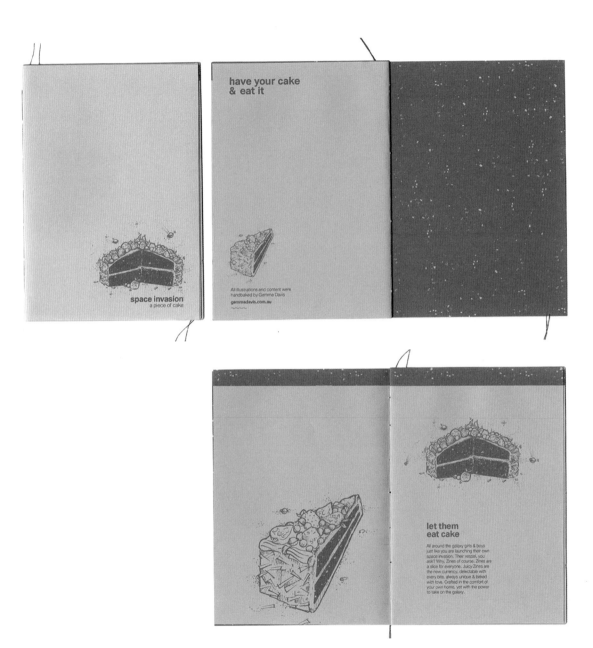

space invasion
a piece of cake

have your cake
& eat it

All illustrations and content were
handbaked by Gemma Davis
gemmadavis.com.au

let them
eat cake

All around the galaxy girls & boys
just like you are launching their own
space invasion. Their vessel, you
ask? Why, Zines of course. Zines are
a slice for everyone. Juicy Zines are
the new currency, delectable with
every bite, always unique & baked
with love. Crafted in the comfort of
your own home, yet with the power
to take on the galaxy.

ingredients

1/2 cup of love
3ml of dedication
1 bottle essence of home
3 diced vulnerability
1 pinch of transparency
1 cup of authenticity
1/4 litre of personal touch
3 tears of emotion
4 grams of mess
1 box of freedom

60%*	70%*	60%*
embodied community	marginalised voice	new vibe of value

* percentage of recommended daily intake

truly nothing tastes quite so good as a homebaked zine

Anyone can bake their own zine. With no rules & the equipment in the home of every boy and girl, you too can make a zine. In fact, zines can't be purchased at your local bakery.

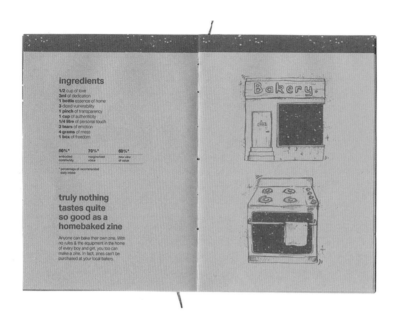

method

Begin your zine by tippling a whole bottle of essence of home in a large mixing bowl. Add 4 pieces of home and 1 cup of authenticity unsifted to the mix and stir it well.

In every zine you bake is a little bit of you. Your mark is emblazoned across the atmos, traced by all who taste it. You are the centre of your own zineverse and all you share it with will be your allies and hear your voice.

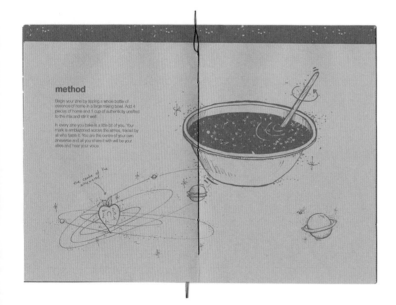

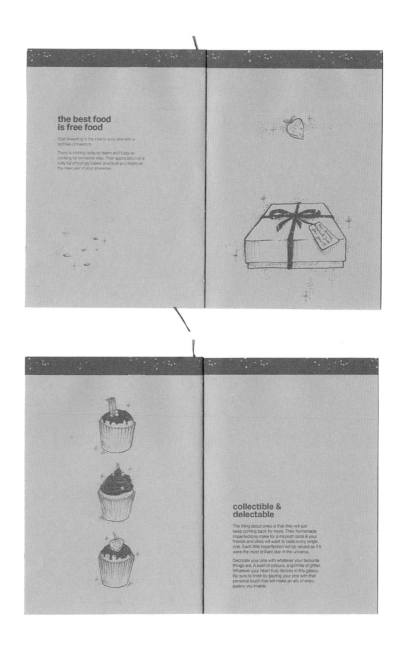

the best food
is free food

Start kneading in the love to your zine with a sprinkle of freedom.

There is nothing quite so warm and fuzzy as cooking for someone else. Their appreciation of a belly full of lovingly baked zine is all you desire as the new ruler of your zineverse.

collectible &
delectable

The thing about zines is that they will just keep coming back for more. Their homemade imperfections make for a moorish taste & your friends and allies will want to taste every single one. Each little imperfection will be valued as if it were the most brilliant star in the universe.

Decorate your zine with whatever your favourite things are. A swirl of colours, a sprinkle of glitter. Whatever your heart truly desires in this galaxy. Be sure to finish by glazing your zine with that personal touch that will make an ally of every galaxy you invade.

MG POSANI

The Power of Creating One's Own Content

VERONA ⇔ MILANO